STREET SPIRIT

THE POWER OF PROTEST AND MISCHIEF

STEVE CRAWSHAW
WITH A FOREWORD BY AI WEIWEI

First published in Great Britain in 2017 by LOM Art, an imprint of
Michael O'Mara Books Limited
9 Lion Yard, Tremadoc Road
London SW4 7NQ

A CIP catalogue record for this book is available from the British Library.

Papers used by Michael O'Mara Books Limited are natural, recyclable products made
from wood grown in sustainable forests. The manufacturing processes conform to the
environmental regulations of the country of origin.

ISBN: 978-1-910552-30-8 in hardback print format
ISBN: 978-1-78243-562-4 in e-book format

1 2 3 4 5 6 7 8 9 10

www.mombooks.com

Cover design by Dan Mogford
Designed by Ana Bjezancevic
Typeset by Greg Stevenson
Cover image © Fabian Bimmer / AP / Press Association Images

Printed and bound in Malaysia

To the memory of Jo Cox, who did so much for a better world.

'She showed us you can be small – and still be a giant.'
MALALA YOUSAFZAI

'I have no symptoms, I have opinions.'

**'Your opinions are your symptoms.
Your disease is dissent.'**

TOM STOPPARD, *EVERY GOOD BOY
DESERVES FAVOUR*

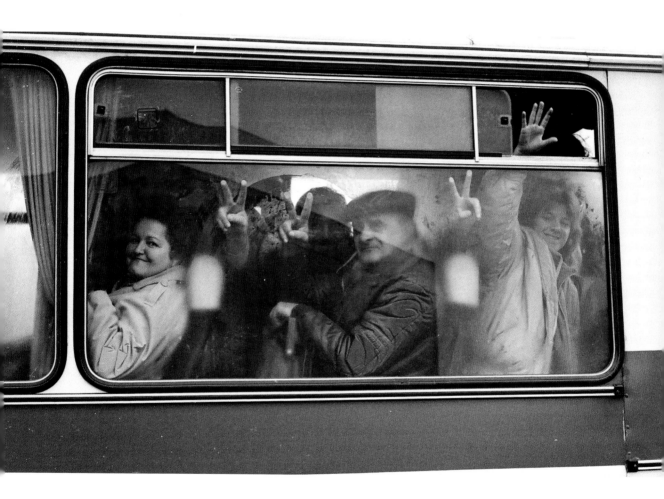

Prague, Czechoslovakia, November 1989.
Riding to the 'Velvet Revolution'. Mass
protests (and jangled keys) ended forty years
of one-party rule in just a week (see pages
14–15). *Photo by Steve Crawshaw.*

CONTENTS

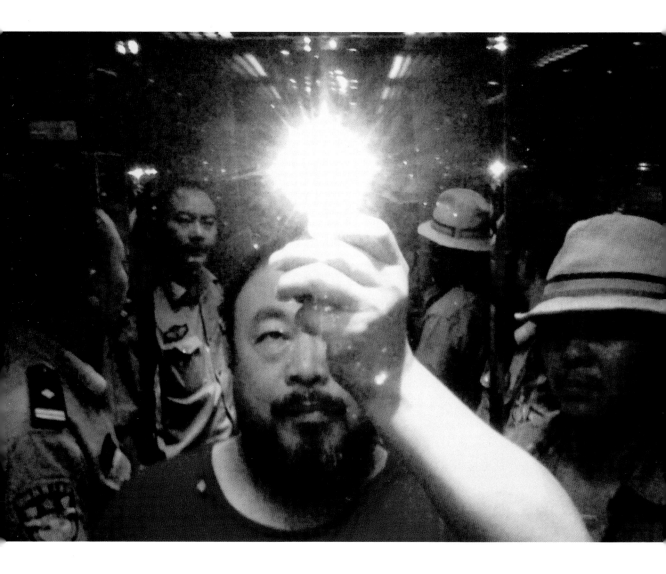

Chengdu, China, August 2009. The artist
Ai Weiwei's determination to document
the thousands who died in the Sichuan
earthquake due to shoddy and corrupt
construction methods infuriated the
authorities, who came knocking on the door
at 3 a.m. Ai Weiwei was severely beaten
(and later hospitalized). While under arrest
in the elevator, he took this photograph,
and shared the image with the world.

'Never retreat. Retweet.'
AI WEIWEI

FOREWORD: Of Ice and Fire

by Ai Weiwei

When a totalitarian society faces creative protests, it is like ice meeting fire. Authoritarian rule is serious and incapable of humour. It exercises strict control over thoughts, to prevent the rise of ideas other than its own. There is no room for communication or negotiation, because otherwise it would lose ground. Often we see protests held for legitimate reasons, yet executed with a lack of creativity. Only art and creative acts can resolve the repressive power of an authoritarian regime. They are efficient, human, intelligent.

Change is not a matter of belief. It is as inevitable as evolution. Over the centuries, human history has been impressive with its constant change. The only surprise is that the changes keep happening, faster and faster. They are beyond our prediction. The question is not whether changes will happen or not. Change can happen at any time, anywhere. It is happening now.

Street Spirit is a relevant and powerful book for our times. It collects the possibilities of change, as well as the emotions, expressions and languages within. No matter what kind of society we live in, it takes the individual to rebel and exercise civil disobedience for those in power to recognize public concerns. The only effective expression for protest is creative expression.

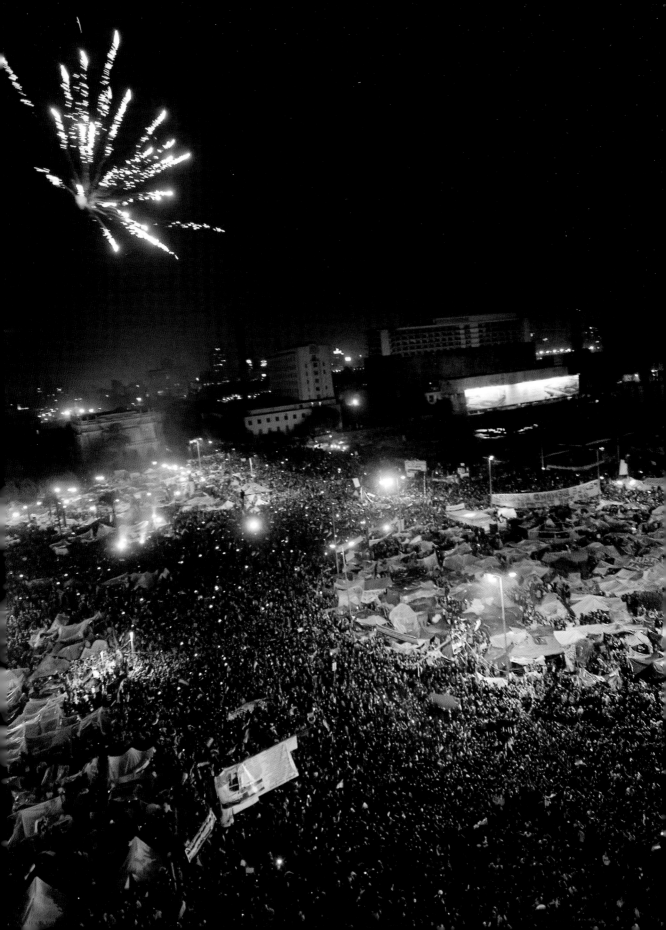

INTRODUCTION

It is always easy to find explanations for why it is futile to take action, and why those who seek change are misguided dreamers. The US Ambassador to Egypt was by no means alone when in December 2008 – in a secret cable, later revealed by WikiLeaks – she informed her colleagues in Washington that those in Egypt who hoped non-violent protest might unseat the corrupt and brutal government of President Hosni Mubarak by 2011 were 'highly unrealistic'.

Two years later, a now historic Facebook post served as an indirect riposte to Ambassador Margaret Scobey and her dismissive conclusion. On 18 January 2011, Asmaa Mahfouz, one of the leaders of the 6 April Youth Movement that the ambassador had been so unimpressed by, sat down in her apartment and recorded a message to her fellow Egyptians.

Mahfouz spoke for four passionate, uninterrupted minutes. 'I'm making this video message to give you one simple message,' she declared. 'We want to go down to Tahrir Square on 25 January ... We'll go down and demand our rights, our fundamental human rights.'

Mahfouz addressed head-on the perception that change in Mubarak's Egypt was unachievable. 'Whoever says it is not worth it because there will only be a handful of people, I want to tell him, "You are the reason for this",' the twenty-six-year-old said. 'Sitting at home and just watching us on the news or Facebook leads to our humiliation.'

On Facebook and YouTube, Mahfouz's video went viral – and Egyptians did not sit at home. On 25 January and in the days that followed, millions poured on to the streets of Cairo and across Egypt. President Mubarak, who had held so tightly to power for thirty years, resigned after eighteen days of protests.

In the years since then, the news from Egypt has often seemed bleak. In President Abdel Fattah al-Sisi's Egypt, those who speak up for basic rights again face threats to life and liberty. But Egyptian novelist Ahdaf Soueif, remembering back to what she calls Egypt's 'eighteen golden days', has argued that the story is not yet over.

Tahrir Square, Cairo, 11 February 2011. After eighteen days of protests, finally the announcement: 'In these difficult circumstances ... President Hosni Mubarak has decided to leave the position of the presidency.'

There is a core, a resolute core that does not lose sight of the aims of the revolution – bread, freedom, social justice – and what those bring of human dignity; that knows … that the people – even if they digress onto a side street – will return to insist on their original path and their essential aims.

Hossam Bahgat, a human rights activist, describes the regime as 'brutal, and at the same time shaky'. In short, the ending is not yet written.

———

There was nothing unusual about Ambassador Scobey's unwillingness to believe that non-violent protest could unseat a powerful, unloved leader. The reluctance by self-described 'realists' to accept the possibilities of change has been a constant throughout history. But again and again, the realists have been trumped by those who challenge existing realities. The courage of those who seek a better and more just world has regularly defied certainties that seem set in stone.

Nobel Prize-winning author Czesław Miłosz identified one reason why sceptics sometimes get it wrong. 'Our natural tendency to place the possible in the past,' he wrote, 'means that we often overlook the acts of our contemporaries, who defy the presumably unmovable order of things – and thus achieve what has at first seemed impossible.'

It was when I was living in Miłosz's native Poland in 1980 that I first saw the 'unmovable order of things' turned upside down. When strikes began in the Polish shipyards in August of that year, the economic demands quickly escalated to include the creation of a free trade union. Western commentators insisted that such demands were unachievable within the context of the Soviet-imposed system, in place since 1945.

In London, *The Times* echoed the consensus when it concluded that the Polish authorities 'clearly' could not agree to the demand for free trade unions. This was obvious because 'the Russians would not agree'. The paper drew comfort from its view that the 'romantic and volatile Pole of tradition' was now 'less in evidence'. Put differently, the paper hoped Poles would be sensible enough to demand only what the authorities were already prepared to give. It didn't turn out that way.

Fears of a violent crackdown were well grounded. The Russian leader,

Leonid Brezhnev, was known for invading countries that stepped out of line, under what came to be known as the Brezhnev Doctrine. He had sent tanks into Czechoslovakia in 1968, and into Afghanistan in 1979. Omens for peaceful change were poor.

Against expectations, however, the Communist authorities backed down in the face of the strikers' demands, which were supported by millions across the country. Radio and television programmes were interrupted for a live broadcast of the surrender. Across Poland, viewers watched in cheerful disbelief as the strike leader, Lech Wałęsa, shook hands and sat as an equal beside the country's deputy prime minister. The government agreed to the strikers' twenty-one demands – including legalization of free trade unions, and freedom of speech and the media.

In effect (though everybody avoided saying so), the Solidarity trade union became a legalized informal opposition, at a time when a tolerated opposition within the Soviet bloc seemed about as thinkable as multi-party elections might be in North Korea today. That signing ceremony in the Gdańsk shipyards on 31 August 1980 was a pinch-yourself moment, paving the way for many changes yet to come.

The mood seemed short-lived. Sixteen months after Solidarity's victory, tanks rolled on to the streets of Poland. Martial law was declared in December 1981. Solidarity was banned and its leaders arrested. The sceptics could claim they had been right all along.

But, despite all the arrests and deaths, things never quite went back to square one. Poles' 'unreal' hopes remained. In 1985, from inside his jail cell, dissident Adam Michnik wrote of what he had witnessed when released under an amnesty the previous year. His experience had 'exceeded not just my expectations but even my dreams'. This was, he said, 'the barren twilight' of the totalitarian world. He wrote, with a confidence that would no doubt have persuaded most Western politicians to label him as a naïve dreamer: 'I am not afraid of the generals' fire. There is no greatness about them: lies and force are their weapons … I am sure that we shall win. Sooner or later, but I think sooner, we shall leave the prisons and come out of the underground on to the bright square of freedom.'

Michnik was right about 'sooner or later, but I think sooner'. Solidarity, supposedly dead and buried, was re-legalized less than four years later. Solidarity candidates stood for parliament in June 1989.

A popular election poster, plastered on walls and lamp posts across

Poland, showed Gary Cooper in sheriff's gear with a Solidarity badge in his lapel and a ballot paper in his hand. 'High Noon', the slogan declared. And so it proved. In the freely elected chamber, an almost embarrassing ninety-nine out of a hundred seats went to Solidarity. The Communists gave up power.

———

Too often, political leaders seem reluctant to believe that citizens have much of a role to play when it comes to bringing about major changes in the world.

As I travelled through Eastern Europe during the dramatic summer and autumn of 1989, it was striking to note that Western politicians and Communist rulers shared one thing in common: both sides found it impossible to imagine that the essentials would ever really change. Above all, they thought real change could only come from powerful politicians like themselves – including and most obviously from inside the Kremlin.

The Berlin Wall – that ugly and conspicuous symbol of the Cold War, which sliced a continent in two – was treated as an obstacle to be negotiated, not removed. President Reagan had in 1987 called on Mikhail Gorbachev, the reformist Soviet leader appointed two years earlier, to 'tear down this wall'. But it was a soundbite, not a prescription for change. Neither Reagan nor Gorbachev actually expected the Wall to fall.

In East Germany, however – as in Poland – popular courage helped make the impossible inevitable. In the summer and autumn of 1989, tens of thousands of people flooded out of East Germany via the newly opened Hungarian border. The exodus caused one set of problems for the East German government. But the biggest pressures came not from those who left, but from those who stayed behind.

In that respect, one day marked a turning point. On the evening of 9 October 1989, in the southern city of Leipzig, I witnessed a series of extraordinary events – or rather, an extraordinary series of non-events. The unique drama of that day consisted, above all, of one thing: that nothing happened.

The backdrop was threatening. The East German authorities had hoped they could stop the growing weekly protests in Leipzig literally dead. They

announced their plans with a published warning. A letter to the local paper declared a willingness to stop 'counter-revolutionary actions' (otherwise known as peaceful protests). This would happen, if need be, 'with weapons in our hands'. The warning came just four months after the massacre in Tiananmen Square in Beijing, which the East German authorities had publicly praised. The meaning of the threat was clear to all.

The authorities put Leipzig into lockdown ahead of 9 October. Foreign journalists in East Berlin (where we had been attending East Germany's self-congratulatory fortieth birthday celebrations, attended by Gorbachev himself) were forbidden to travel to the city. The secret police, the Stasi, threw out reporters who had already arrived. All looked set for the endgame. Guns and ammunition were issued. Hospital wards were cleared. Before the evening protest began, I counted sixteen trucks filled with armed state militias in one side street alone.

Two thousand of us crammed into the medieval Church of St Nicholas for the prayers for peace that preceded the Monday protests. Tens of thousands more gathered outside. Cries of 'We are the people!' echoed in through the tall Gothic windows.

Everyone going on the march that evening knew they were risking their lives. Earlier that day, I had witnessed one of the protest leaders trying to forbid his daughter to go on the march. He was allowed to die, ran the implied logic, she was not. I had identified a small alleyway just off the main square where I reckoned it would be safe to hide, if or when the shooting started. But that didn't reduce my fear. All in the vast crowd presumably shared the same feeling of dread, as they walked across Karl Marx Square chanting 'Keine Gewalt!' – 'No violence!'

But then – nothing happened. There was no shooting. There were not even the beatings or arrests that had become standard fare. Gradually, it became clear: there would be no attack tonight. Unbelievably, there would be no violence of any kind. Instead, the huge crowds walked unhindered – past the railway station, up past the secret police headquarters, and back down to Karl Marx Square. A mood of dazed euphoria began to take over. People smiled, laughed and offered flowers to militias. The protest ended around 8 p.m., and with it the unchallenged power of the East German state.

The authorities had calculated that threats of lethal force would persuade people to stay at home. In fact, many *more* people came out that evening than ever before. As one woman told me later, describing the

moment when she realized that the regime had backed down, 'I felt as if I could fly. It was the most fantastic day I have ever known.'

The events of that day came to be known as 'the miracle of Leipzig'. The Stasi interrogated me and threw me out of the city, once they realized I had witnessed and reported on this historic day. But that did nothing to diminish my sense of privilege for having been there.

From 9 October onwards, changes in East Germany went into fast-forward, in what the Polish writer Ryszard Kapuściński, describing the Iranian Revolution of 1978–79, had called a final 'zigzag towards the precipice'. In an article for the *Independent* a few weeks after Leipzig, I described how the regime had been forced to make more and more concessions. I drew what seemed the obvious conclusion, if one took seriously the implications of the courage of Leipzig and all that had happened since then: 'The removal of the Wall is not just a possibility. It is one of the few logical options left.' The Berlin Wall broke open the day after those words were published – on 9 November, a month to the day after the 'miracle of Leipzig'.

And yet, despite everything that had happened in previous weeks and months, the fall of the Berlin Wall took politicians by surprise. They were startled because it never occurred to them that citizens could achieve so much by themselves. That reluctance to take individual courage seriously remains relevant today.

'It is up to all of us to try – and those that say individuals are not capable of changing anything are only looking for excuses.'

VÁCLAV HAVEL

The Leipzig factor – a quietly unstoppable force, against an apparently immovable object – gave reality to the theories of Václav Havel, Czech dissident and playwright, who later became his country's president.

In his 1978 essay 'Power of the Powerless' – written in the depths of the Cold War, where there seemed to be no light at the end of the tunnel – Havel talks of choosing to 'live in truth'. He muses on the possibilities of change, in a context where it seems nothing can change. He gives

the example of a hypothetical greengrocer who defies the authorities by refusing to put the propaganda slogans in the window that were delivered to him 'along with the onions and the carrots'.

> *Let us now imagine that one day something in our greengrocer snaps and he stops putting up the slogans merely to ingratiate himself … In this revolt the greengrocer steps out of living within the lie. He rejects the ritual and breaks the rules of the game … His revolt is an attempt to live within the truth …*
>
> *He has said that the emperor is naked. And because the emperor is in fact naked, something extremely dangerous has happened: by his action, the greengrocer has addressed the world. He has enabled everyone to peer behind the curtain. He has shown everyone that it is possible to live within the truth.*

The greengrocer's small act of resistance gets him in trouble, and nothing appears to change. But, Havel asked, what if an entire country were to defy the authorities, along with the greengrocer? For his belief in the possibilities of change, Havel was mocked. As he put it later, he was seen as 'a Czech Don Quixote, tilting at unassailable windmills'. Eleven years later, though, Havel was proved right – in his own country and elsewhere.

Ten days before the fall of the Berlin Wall, I met with Havel in Prague. He spoke of his country as 'a pressure cooker, waiting to explode'. Just three weeks later, the cooker exploded, in what came to be known as the 'Velvet Revolution'. As in Leipzig six weeks earlier, official violence – against peaceful protesters whose only crime was to demand basic freedoms for their country – persuaded *more* people, not fewer, to go out on the streets. One man later described his feelings when he decided to resist for the first time: 'As I lay on the ground and police beat me, I felt free.'

The traditional final rhyming couplet in Czech fairy tales goes, 'The bell is ringing – and the story is over.' In Prague, hundreds of thousands went out on Wenceslas Square every afternoon, jangling little bells and keys to tell the country's rulers that their time was now over. After just a week of protests, on the evening of 24 November 1989, the government resigned en masse. Quiet Prague went wild. A month later, the parliament elected Havel – dismissed by the prime minister as a 'nobody' only weeks before the revolution – as the country's president.

'Like the hobbits on the journey to Mordor . . . the little guys say: "I will take the ring".'

SRDJA POPOVIĆ, SERB ACTIVIST AND AUTHOR OF
BLUEPRINT FOR REVOLUTION

Humour, as an element of rebellion, helps unlock many doors – including and especially in dark circumstances.

Throughout the 1990s, Slobodan Milošević ruled Serbia with an iron fist. He seemed impossible to dislodge, and Serb opposition leaders argued with each other as much as they did with Milošević. The youth movement Otpor ('Resistance') helped change that. Creativity became a key weapon in their non-violent armoury. On one occasion, Otpor pasted an image of Milošević on to a barrel and encouraged passers-by in the main shopping street of Belgrade to pick up a baseball bat and 'smash his face for just a dinar' – which, after a nervous start, people did with enthusiasm. The authorities weren't sure how to react. The organizers were nowhere to be seen (they were watching from a nearby café), and 'barrel-bashing' wasn't an easily identifiable crime. For lack of a better target, police ended up detaining (and being photographed detaining) the barrel instead. Milošević looked less invulnerable, and the authorities looked plain foolish.

In 2000, with the help of Otpor – which had finally been able to persuade the established opposition politicians to unite behind a single candidate – those who stood against Milošević were united as never before. When Milošević falsely claimed victory in elections that year, hundreds of thousands took to the streets to demand he back down.

Eager not to miss the final episode of a drama that I had followed for many years, I slipped into Serbia on the night train from neighbouring Montenegro, in possession of a visa I had bought in a Montenegrin bar. (Unwilling to let the world witness what was happening, the authorities refused journalists all entry into Serbia and had thrown out those who were already there, so it seemed appropriate to cut corners. Purchasing a visa of dubious provenance is neither recommended nor to be repeated; in the circumstances, however, it was difficult to regret.)

Thus, I was there for the dénouement – including the extraordinary Birnam Wood scenes of 5 October 2000, when vast numbers travelled from around the country to demand that Serbia's own Macbeth must finally go. The roads around Belgrade were jammed solid with cars and buses filled with people heading into the capital, laughing and hooting for a victory that they had not yet achieved.

The events of that day included a bulldozer driver who drove his vehicle across the country and finally into the entrance to the building of the hated state TV. (The uprising became known as the 'bulldozer revolution'.) The regime surrendered the same evening, after police threw away their jackets and joined protesters. As the headline in a previously pro-Milošević paper declared the next day, 'The will of the people has conquered.'

Milošević told the nation that he had 'just learned' that he had lost the election, after all. Eight months later, he was delivered to the war crimes tribunal in The Hague. He died behind bars in 2006.

The protests against Milošević succeeded for many different reasons. Protesters had courage, creativity and humour. And their humour gave them confidence. The most successful Otpor slogan, dreamed up one evening in a Belgrade kitchen, declared, 'Gotov je' ('He's finished'). Everything else flowed from that.

―――――

'It is not power that corrupts but fear. Fear of losing power corrupts those who wield it and fear of the scourge of power corrupts those who are subject to it.'

AUNG SAN SUU KYI

Cracks in the façade often appear in surprising places. Burma, or Myanmar, is another example of a country where an apparently invincible regime was eventually shown to be less invincible than it thought.

In 1998, during one of the few periods when she was not under house arrest, I met and interviewed the Burmese opposition leader Aung San Suu Kyi. Shortly afterwards, photographer Tom Pilston and I were detained and interrogated, for the crime of meeting the woman who the Burmese

people called 'The Lady'. But Aung San Suu Kyi was right when she told us, 'This is not a sustainable situation. Change will come.' One of our arresting officers explained why it was forbidden to meet with Aung San Suu Kyi. It was simple, he explained, 'She has wrong views.'

But things are not always as monolithic as they seem. A curious twist to our Burmese story came as Tom and I were being deported from the country and put on a blacklist that would last for the next fourteen years. Not everybody, it turned out, was on-message. One of the officials tasked with throwing us out patted us on the back as he was doing so, and wished us good luck with our work.

The same pattern appears, over and over. The military monolith that had controlled Myanmar for half a century finally crumbled in the face of popular aspirations for change. After huge protests in 2007, Aung San Suu Kyi was released in 2010. In 2015, her party gained a parliamentary majority. In 2016, the woman with 'wrong views' became Myanmar's *de facto* leader.

———

Anybody who is interested in the subject of non-violent protest must contend with the argument that it can only be successful in 'easy' cases where the government is already inclined to give way, and protesters are thus merely pushing at an open door. Over the years, that argument has become increasingly difficult to sustain.

For decades, Gene Sharp – now in his eighties, working from his home in east Boston – has written about the power of non-violent protest. For much of that time, his message was ignored. Non-violence and its impact was seen as a fringe interest. In recent years, however, Sharp has gained global attention for the first time. The 'Clausewitz of non-violent warfare' has been nominated for the Nobel Peace Prize, and in 2011 an award-winning documentary about his work was released – perhaps fittingly, in the same week that the Occupy protests began in New York.

One of Sharp's best-known books is *From Dictatorship to Democracy*, a handbook for non-violent troublemakers that has been translated into dozens of languages. In it, Sharp quotes a Chinese story about the 'monkey master' who demands that monkeys give him the fruit they collected, and flogs those who disobey. The monkeys 'suffered bitterly' but dared not

complain. One day, the monkeys rebelled and 'took the fruits the old man had in storage, brought all with them to the woods, and never returned'. The fable concludes, 'Some men in the world rule their people by tricks and not by righteous principles ... As soon as their people become enlightened, their tricks no longer work.'

In truth, even when people become 'enlightened', tyrannical rulers are more inventive than the monkey master, as we have repeatedly seen in recent years. Real-life monkey masters deploy deadly tricks to cling to power. In Syria, creative acts of non-violent resistance – forbidden music in litterbins, blood-red water in fountains, ping-pong balls with rebellious slogans tumbling down the streets, and much more – have long since seemed overtaken by the country's unending bloodshed. Hundreds of thousands have died and millions have been forced to flee their homes, even as the world looked away.

Unfettered violence is, however, by no means the trump card that some – rulers and ruled alike – still sometimes believe it to be. In 2011, two political scientists, Erica Chenoweth and Maria Stephan, published a study of non-violent protest. Chenoweth had begun the research as a sceptic. She believed that those who argued for the efficacy of non-violent action were 'well intentioned but dangerously naïve'. From Chenoweth's original perspective, 'Although it was tragic, it was logical for people to use violence to bring about change.' She told a workshop organized by the International Center on Nonviolent Conflict that successful examples of using non-violent resistance to achieve change were 'probably exceptions'.

But Chenoweth was challenged to analyse the evidence. Maria Stephan, her soon-to-be co-author, demanded, 'Are you curious enough to study these questions empirically?' And so they did just that. Chenoweth and Stephan went on to track the impact of hundreds of violent and non-violent campaigns for change over the past hundred years. In Chenoweth's words, 'The data blew me away.' In a data-packed comparative analysis, the authors found that non-violent campaigns were twice as likely to succeed as violent insurgencies – thus partly echoing the words of Archbishop Desmond Tutu, who played a key role in South Africa's liberation: 'A human being looking at it would say that arms are the most dangerous things that a tyrant needs to fear. But in fact, no – it is when people decide they want to be free. Once they have made up their minds to that, there is nothing that will stop them.'

Chenoweth and Stephan concluded:

In the last fifty years civil resistance has become increasingly frequent and effective, whereas violent insurgencies have become increasingly rare and unsuccessful. This is true even in extremely repressive, authoritarian conditions where we might expect non-violent resistance to fail.

Where violence *did* achieve change, the track record showed – in a finding which is unsurprising but too often ignored – that the prospects of achieving stability and democracy in the years that followed are dramatically reduced.

––––––

The stories in this book pay homage to those who have defied conventional wisdom and thus created or paved the way for change. There are stories of surprise and mischief – 'laughtivism', in the words of Serb activist Srdja Popović. There are stories where the sheer weight of numbers helps make change inevitable. There are stories where the pivot has proved to be the courage or decency of a single individual. There are stories where artists – working in theatre, music or visual arts – have challenged the status quo. There are stories of the ever-changing world of social media – allowing small acts to have global resonance, bringing large numbers of people together for a single purpose, and providing new ways of revealing abuses to the world.

As always, there are many reasons for pessimism. But experience teaches us: we should not underestimate the impact of creativity, courage and non-violence in helping to create a different world.

'Does the flap of a butterfly's wings in Brazil set off a tornado in Texas?'

EDWARD LORENZ, METEOROLOGIST

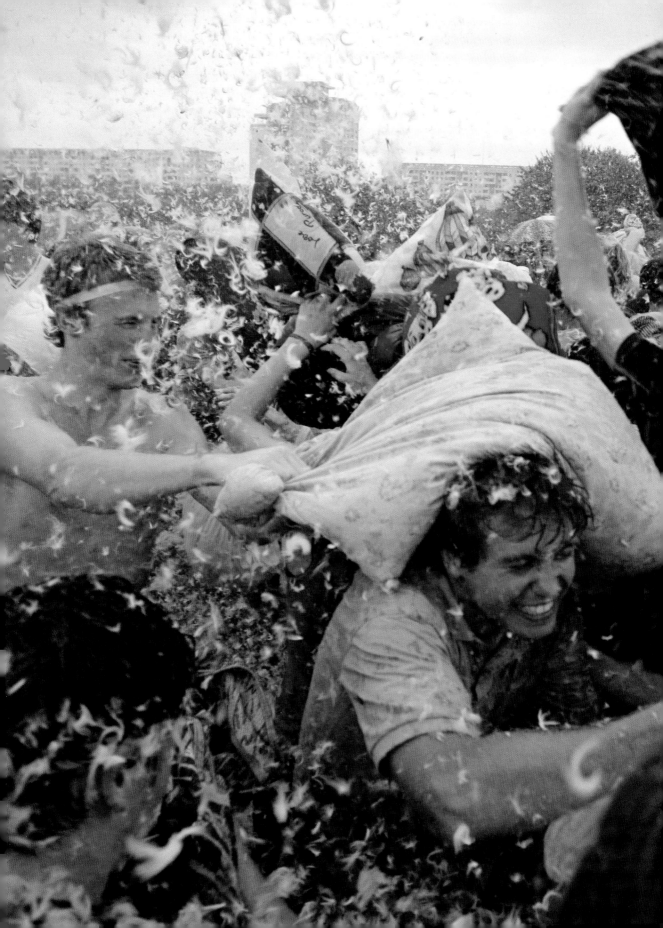

ONE

..

Not Protesting,
Just Strolling

'A hero is somebody who does what he can.'
ROMAIN ROLLAND

Minsk, Belarus, 15 July 2010. In Belarus, even a pillow fight – in mock-commemoration of a 600-year-old battle – is treated as a threat to national security. On this day, fifty people were arrested.

It is difficult to organize a public protest if you know in advance that the result will be arrest, beating or torture. But protesters over the years have found ways of demonstrating, even while appearing not to. 'Me, a protester? You must have misunderstood!' is the message to uniformed and plain-clothes police alike.

Admittedly, the authorities can see that they are dealing with an anti-government protest. It is, after all, difficult to imagine that demonstrative praise for an unpopular government can be anything but ironic. But how can police and security forces distinguish between those who are indeed protesting and those who – genuinely – just happen to be out and about? It can be as simple as eating a sandwich, clapping or merely standing still. Sometimes, less is more.

FORBIDDEN APPLAUSE

Authoritarian leaders crave or demand applause. Official newspaper accounts of Stalin's speeches were sprinkled with bracketed descriptions ranging from 'stormy applause' to 'stormy, prolonged applause' and finally culminating – through devotion or fear, or a mixture of the two – in that dictator's ultimate feel-good moment, 'stormy, prolonged applause that became an ovation'. In Stalin's Russia, just as in Saddam Hussein's Iraq or in North Korea today, the failure to clap enthusiastically enough could be punished as a grave crime.

In the former Soviet republic of Belarus, that principle was turned on its head. Protesters applauded the president – and the authorities locked them up for doing so. The authorities' logic was compelling. There are few good reasons to applaud Alexander Lukashenko, who has been described as 'Europe's last dictator'. Therefore, the enthusiastic applause that took place on a weekly basis for several months in 2011 must have been seeking to mock him.

In response to this outbreak of disloyal loyalty, the authorities forbade all applause. Those who continued to clap were arrested for 'hooliganism'. (The authorities cast their net wide: one of those arrested for illegal clapping only had one arm.) Even presidential

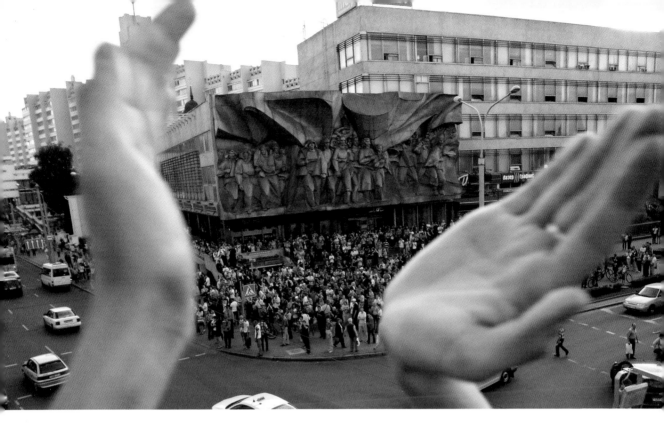

yes-men, usually first to jump up with their 'stormy applause', sat silent while the president spoke, in case their clapping might be perceived as arrestable irony.

The ban on applause was just the beginning. The authorities followed up with a ban on all gatherings, 'for the purpose of a form of action or inaction'. For Lukashenko, it would appear that those who chose to do something and those who chose to do nothing could both seem equally subversive.

The Belarus Free Theatre, a theatre group whose directors, actors and even audiences have repeatedly been arrested for telling too many truths, has a show called *Generation Jeans*. (The title is a reference to the 'Jeans Revolution' of 2006, where denim was used as an improvised protesters' flag.) *Generation Jeans* concludes, 'Sooner or later, all jail terms end. And so does dictatorship.'

Belarus, June 2011. Crowds gather to 'applaud' President Lukashenko (above). Dozens were arrested for their mock loyalty. Some of those who were arrested didn't seem very cowed (opposite).

JASMINE AND BIG MACS

Protesting in China is challenging and dangerous. But Chinese people have found unusual ways of making their concerns heard.

In 2011, the peaceful 'Jasmine Revolution' in Tunisia – first in the series of uprisings that became known as the Arab Spring – showed that the voices of ordinary citizens were being heard more loudly than ever before. Tunisia's corrupt president was obliged to flee. Chinese people who wanted more freedoms for their country were inspired by what they saw in Tunisia. They wanted to show solidarity with those on the other side of the world who had achieved extraordinary things.

An official protest in China would inevitably be broken up before it had begun. Instead, organizers encouraged a series of 'strolls' at different locations – outside a busy McDonald's in Beijing, Starbucks in Guangzhou or the Peace Cinema in Shanghai. 'No shouting or slogans, just walking and smiling,' read a statement from a group called the Initiators of the Chinese Jasmine Revolution.

These protests-that-weren't proved a bigger headache for the

Shanghai, China, February 2011. For the jittery authorities, just going for a stroll was reason enough to arrest people.

authorities than might have been expected. Large numbers of uni-formed and plain-clothes police were drafted in, in response to the quiet stroll. But it was difficult to arrest somebody who might – or, alternatively, might not – merely be seeking a cappuccino or a Big Mac. Those who were demanding human rights and those who wanted to eat a hamburger mingled – sometimes deliberately so.

One man sitting in McDonald's said, 'It's a chance to meet each other. It's like preparing for the future.' The authorities reacted with a familiar all-embracing paranoia, bringing in street-cleaning trucks to clear the area, while beating people up at random. Signalling their fear of these non-protests, the government banned the word 'jasmine' as an internet search term.

'**Wherever there is oppression there is resistance.**'
MAO ZEDONG

SHOPPING OR PROTESTING?

When Hong Kong reverted to China in 1997 after a century of British colonial rule, the official slogan was, 'One country, two systems'. In the years since then, Hong Kongers have begun to fear that the line between Hong Kong's freedom and repression on the mainland is becoming dangerously blurred.

In 2014, tens of thousands took part in what became known as the 'umbrella protests', demanding universal suffrage – which the authorities, in turn, were determined not to grant. The umbrellas served as a defence against the tear gas and pepper spray that were deployed against protesters, as well as against the Hong Kong rains.

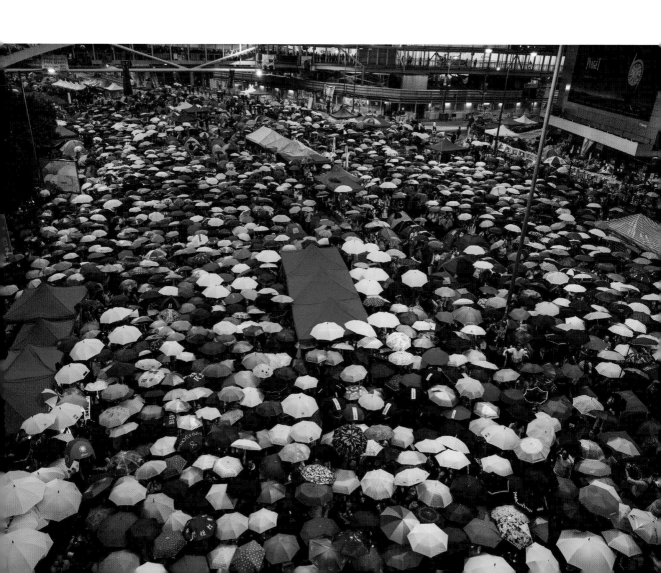

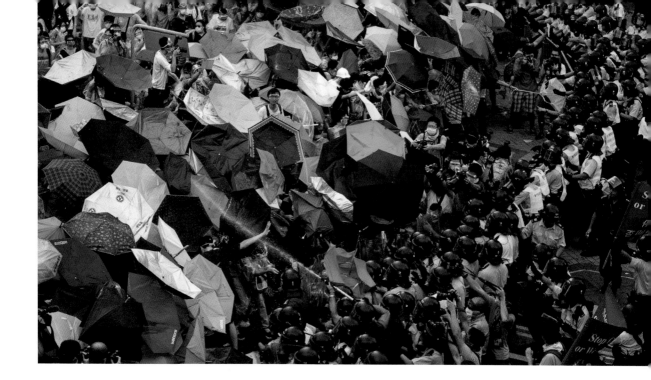

Even after the dispersal of the protests, defiance continued. In November 2014, Hong Kong chief executive CY Leung – mockingly known as 689, because he was installed with that modest number of votes – called for the public to go shopping in the Mong Kok district, to give support to businesses in the area that had been hurt by the protests. The protesters took him at his word. They flooded Mong Kok, shouting 'To shop!', causing official confusion. How could police now make a distinction between shoppers and pretend 'shoppers'?

Today, CY Leung is still having difficulty in finding popularity. His approval ratings are many times lower than his predecessors in the post. In 2016, Facebook made it even harder for him when it launched new ways of reacting to posts. 'Like' was joined by 'love', 'wow', 'sad', 'haha' and 'angry'. CY Leung's Facebook page set world records when a hundred thousand Hong Kongers took the opportunity to react to him as 'angry' within just a few days.

Hong Kong, October 2014. Armed only with umbrellas, tens of thousands faced riot police and tear gas to demand the right to choose their own elected representative.

SUBVERSIVE SANDWICHES

After a military coup in Thailand in 2014, citizens were ordered to be 'happy'. Those who failed to be sufficiently happy were taken off to military camps for what was described as 'attitude adjustment'. Gatherings of more than five people were banned. But Thai people found ways of getting round the ban, by organizing activities that weren't protests – merely activities.

One form of defiance was sandwich-eating, which became a way of saying 'no' to the junta in a discreet, deniable – and yet conspicuous – way, during what became known as 'democracy picnics'. The military responded by arresting those who took the subversive step of eating lunch.

Along with the sandwiches, book-reading became another dangerous activity. Studious types were arrested for demonstratively reading books in public, including George Orwell's *1984*, which the military, perhaps with good reason, clearly believed to be relevant to Thailand's situation.

And the paranoia didn't stop with literature. Even the movies blurred into real life when the three-fingered salute from *The Hunger Games* was adopted by Thai protesters, leading to yet more arrests. This illegal enthusiasm for a movie gesture resulted in some Bangkok cinemas deciding that *The Hunger Games: Mockingjay – Part 1* was subversive fare. They cancelled showings 'for fear of political implications'. They were proved right when students were arrested outside a cinema that went ahead with a showing of the film.

In the meantime, the junta has not backed down. Nor, though, have the protesters. I Love General Prayuth is the name of a Facebook page supposedly in praise of the junta leader. In 2016, eight of its organizers were arrested and charged with sedition. The idea of loving the general was clearly too improbable.

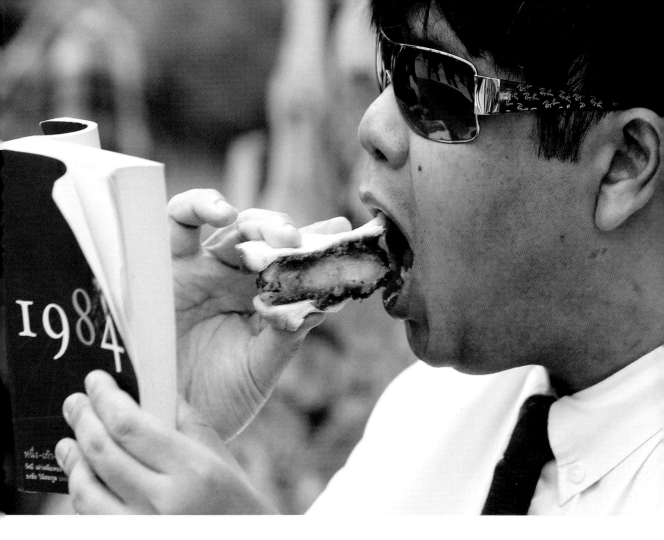

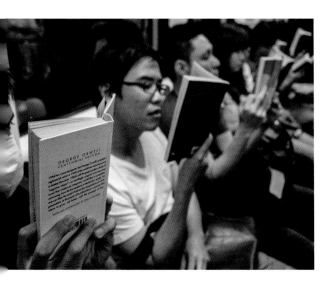

Bangkok, Thailand,
June 2014.
Sandwich-eating
and book-reading
became arrestable
activities according
to the junta.

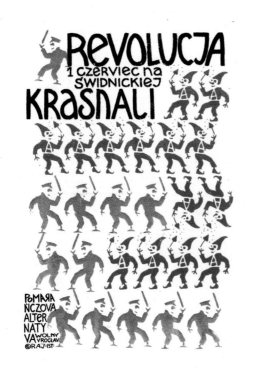

DOC AND GRUMPY VS TANKS

In Poland in 1981, the government put tanks on the streets and declared martial law, reversing historic reforms that had been introduced in the previous year. Solidarity, the free trade union and informal opposition movement, was banned. Thousands were beaten and arrested. Solidarity supporters daubed countless graffiti on walls across Poland in the months and years that followed. The authorities, in turn, kept painting the protest slogans over, leaving a rash of white splodges in their wake. So far, so normal.

And then came the Polish twist. A group called the Orange Alternative decided to confuse the authorities. They once again painted on to the white spaces. But instead of writing more Solidarity slogans – which would yet again be instantly erased – they painted pictures of friendly dwarfs. This put the government in a quandary. On the face of it, the dwarfs – *krasnoludki* or 'little red-hatted folk' – were not obviously subversive. They were, after all, just dwarfs. And yet, the authorities could not help feeling that they were being mocked. The decision came from on high: ban dwarfs.

In advance of a pre-announced 'Revolution of the Dwarfs' in 1988, an illegal leaflet proclaimed, 'The Revolution of the Dwarfs cannot happen without you! Its fate is in your hands.' Participants were asked to wear paper hats and bring rattles and toy trumpets. Instead of the more familiar chant of, 'There is no freedom without Solidarity!', marchers chanted, 'There is no freedom without dwarfs!' For the authorities, this was complicated. Police radios communicated the instructions – a first, perhaps, in world history – 'Arrest all dwarfs!'

In retrospect, the authorities were perhaps right to be worried. Within months of the Revolution of the Dwarfs, the authorities felt obliged to agree to elections in 1989, where Solidarity's victory helped trigger the fall of the Berlin Wall. Grumpy, Doc, Bashful and Sneezy had played their part.

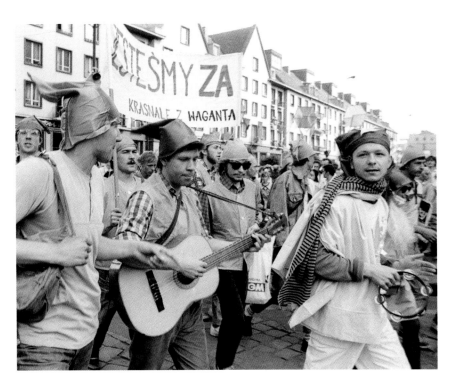

Poland, 1984-88. Poles painted friendly dwarfs in Wrocław and across the country (opposite, right) in response to the authorities' crackdown on graffitied political slogans. In June 1988 they organized a Revolution of the Dwarfs (poster, opposite, left), where participants (left) proclaimed 'There is no freedom without dwarfs.'

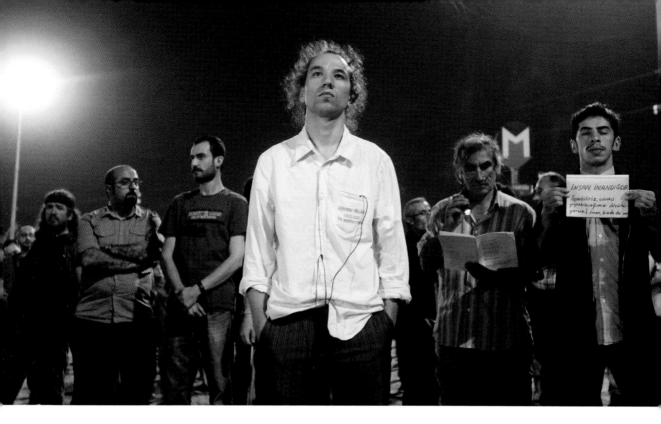

STILLNESS FOR CHANGE

Istanbul, Turkey, June 2013. Erdem Gündüz, the Standing Man (above), stood for hours on Taksim Square. He was joined by others, including, at one point, a mannequin (opposite).

In 2013, millions took to the streets of Istanbul and other Turkish cities, initially voicing environmental concerns about the redevelopment of Gezi Park in the centre of Istanbul, and then with broader demands for political change. The authorities beat, tear-gassed and detained them, even as Prime Minister Recep Tayyip Erdoğan railed against the 'menace' of Twitter. When Erdoğan described the protesters as *çapul*, or 'riffraff', the protesters adopted the intended insult as their own. 'Every day I'm çapuling' became a popular slogan on T-shirts and on walls.

On 15 June 2013, after two weeks of protests, riot police evicted thousands from Gezi Park and the adjoining Taksim Square. The square was sealed off, and the government announced that anybody attempting to remain would be treated as a 'supporter or member of a terrorist organization'. It seemed as if everything was over.

But then, two days later, came Standing Man. The man who appeared on Taksim Square did nothing. He simply stood there for

eight hours. He gazed at the national flag and at the statue of Kemal Atatürk, founder of modern Turkey.

At first, few noticed. Then, people started taking photographs and sharing them on social media. Others joined Standing Man in his slogan-less vigil. The same protest began in other districts and cities. The hashtag #duranadam – 'standing man' – went viral in Turkey and worldwide.

Many followed Erdem Gündüz, artist and Standing Man. Gündüz explained, 'I am just an ordinary citizen of this country. We want our voices to be heard.' Gündüz insisted he was not frightened by threats, 'We will have to keep going.'

In the years since then, the crushing of dissent in Turkey has been worse than ever. But the spirit of Taksim has not died. In 2014, Mücella Yapıcı, a founding member of the Taksim Solidarity group, was among those accused of starting a 'criminal organization'. She was later acquitted, but even as the threat of a possible jail sentence was hanging over her, Yapıcı insisted, 'A new solidarity was born in June, and it's not over.' Erdoğan himself benefited from the defiance. In 2016, in response to an attempted military coup, unarmed crowds (involving many who opposed Erdoğan, but were not keen on a military overthrow) filled the streets and blocked tanks. Even after the coup, Erdoğan still failed to understand the meaning of basic rights. He went on to lock up leading journalists and activists – including those who had spoken up on his behalf and against the coup.

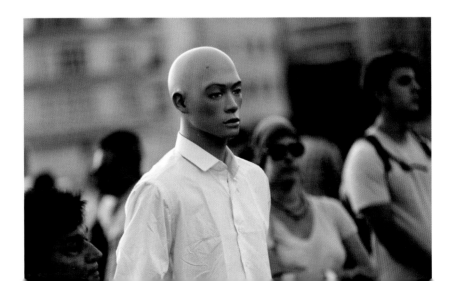

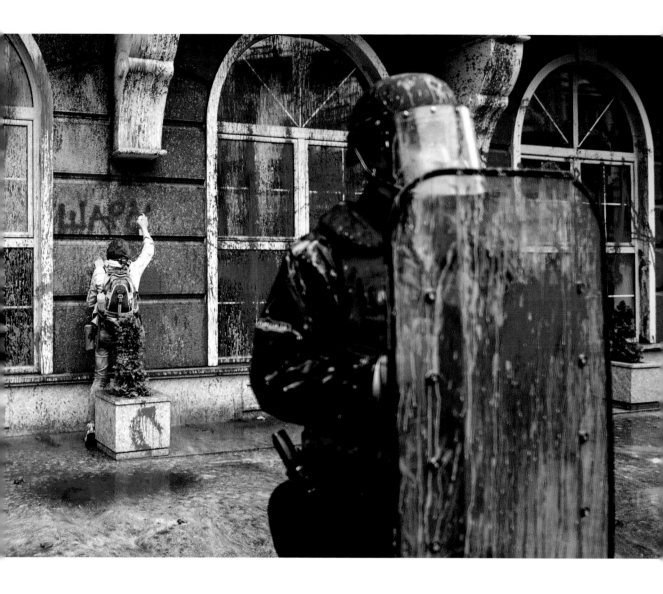

Skopje, Macedonia, May 2016. In the former Yugoslav republic, protesters were enraged by the levels of corruption and by pardons for those facing investigation. In the 'colourful revolution', Macedonians used paint-filled balloons to target grandiose new buildings and nationalist monuments. The building programme cost half a billion euros; the average monthly salary is €350. As one headline put it, 'Let them eat Alexander the Great statues.'

TWO

..

Small Actions, Big Themes

'Small minds are concerned with the extraordinary, great minds with the ordinary.'
BLAISE PASCAL

It might seem that massive repression can be defeated only by equally massive resistance. But small actions can also embody aspirations for larger freedoms.

Such actions are often about choice. Women decide whether they will choose to wear (or not wear) a headscarf. Protesters insist that they, not the government, should decide if they will exercise the basic right to sit behind the wheel of a car. Mischievous Facebook posts can be used to reassert basic rights.

These small choices also confront greater threats. They are often no less dangerous than more dramatic actions, as stories in this chapter make clear. As Vincent Van Gogh wrote, 'The great is a succession of small things that are brought together.'

FLYING FREE

Around the world, many women choose to wear the headscarf for a mix of cultural and religious reasons. Others choose not to wear it. For both groups, that is their right. Some governments, however, are not keen on women exercising those rights.

Many Iranian women regularly defy the authorities with their 'bad hijab' – letting more hair show than the government believes is appropriate. The Iranian morality police – officially, 'guidance patrol' – rebuke or arrest 3 million women every year. In recent years, defiance has gone further – from bad hijab to no hijab, deliberately revealed to the world. In 2014, journalist and activist Masih Alinejad created a Facebook page where she photographed herself without a headscarf and encouraged other women to do the same, arguing that this was not about right or wrong, but about choice: 'My mother wants to wear a scarf. I don't want to wear a scarf. Iran should be for both of us.'

Women submitted their own images to the My Stealthy Freedom page, with hair uncovered and flying in the wind. As one woman put it, 'We love Iran – and that is why we ask for more respect from our own country for women.' The My Stealthy Freedom page has gained more than a million likes.

Other small acts of defiance continue to multiply. An app launched in 2016 crowdsources local information about where the 'guidance patrol' is operating on any given day. The app's slogan: 'Wander freely.'

Masih Alinejad is convinced time is on the women's side. 'The government is really scared of us. They've got weapons, they've got prisons, they've got money, they've got everything. We've got only Facebook. And that still scares them. Why? Because they don't want women to be empowered. They don't want women to be that loud.'

Isfahan, Iran, 2016. This woman posted her defiant and illegal image on the My Stealthy Freedom page. She wrote, 'Freedom will not be idly lurking on the horizon for us, we should be fighting to get it ... I want to live free and run with my wings, not with my feet. My wings represent my laughter without fear ... where my hair has been liberated.'

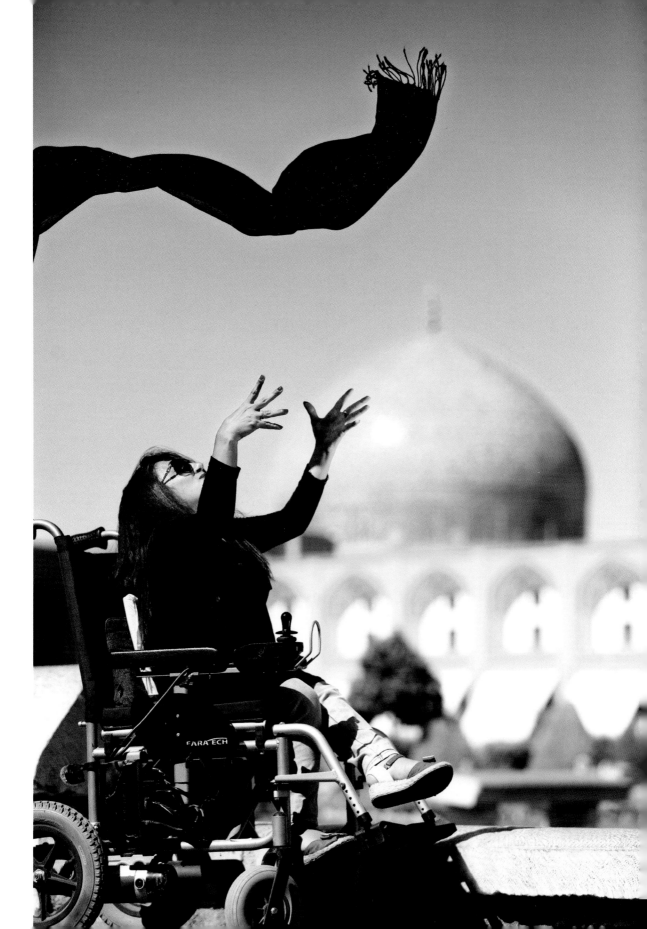

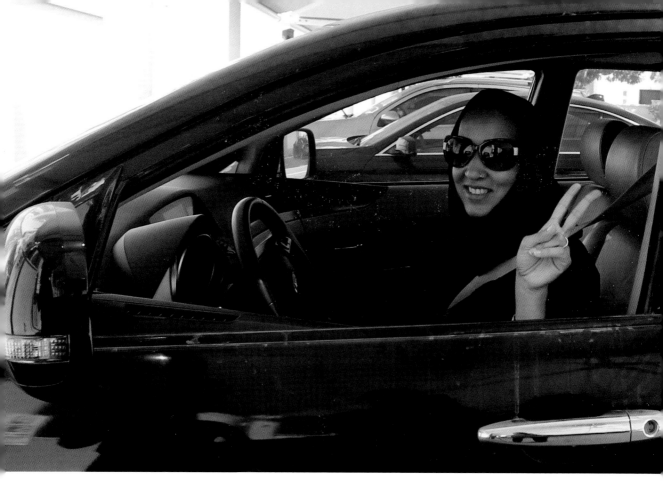

IN THE DRIVING SEAT

ABOVE: The Grand Mufti of Saudi Arabia thinks driving 'exposes women to evil'. Manal al-Sharif (pictured) and others disagree.

In Saudi Arabia, a country treated as a staunch ally by oil-thirsty Western governments, free speech is severely punished. Thus, to take just one example, prisoner of conscience Raif Badawi was sentenced in 2014 to a thousand lashes and ten years in jail, for the crime of expressing peaceful opinions online.

Women's rights are trampled in a range of contexts. The Grand Mufti of Saudi Arabia describes women driving as 'a dangerous matter that exposes women to evil'. But Manal al-Sharif and other Saudi women are fighting back, including with videos of them defying the ban. Loujain al-Hathloul and Maysaa al-Amoudi, two of those who have disobeyed the rules, were briefly jailed in 2014 – after facing trial in a court designed for terrorism offences.

The pressure for change continues. Al-Hathloul's husband, comedian Fahad Albutairi, is co-creator of a music video that echoed Bob Marley with its lyrics: 'No woman, no drive.' The video racked up 13 million views on YouTube. Albutairi quotes Oscar Wilde: 'If you want to tell people the truth, make them laugh – otherwise they'll kill you.'

Saudi writer Maha al-Aqeel believes change is inevitable. 'Many conservatives feel that if women get the right to drive, then that's it, the last bastion of male control will fall. I think it should lead to other changes. That's why those who oppose it are so vehement.'

Manal al-Sharif argues, 'We are only a drop in this world. But the rain starts with a single drop.'

BELOW: Some Saudi women choose to drive quad bikes – legally racing against each other in remote areas, as a way of venting their frustration at the ban on driving cars.

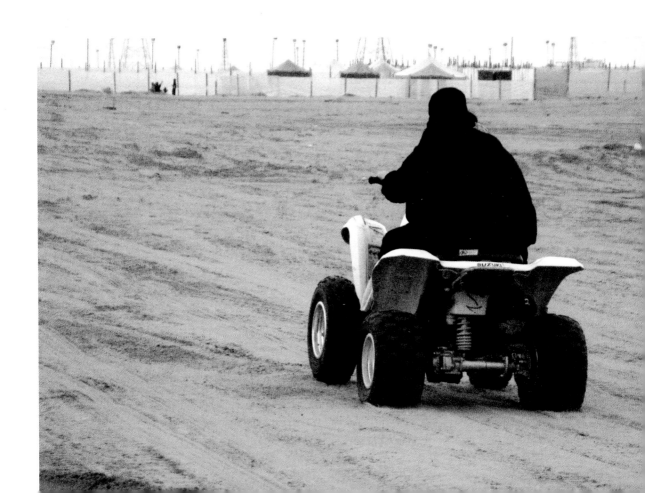

PEEING IN PEACE

There are many contexts in which people around the world are forbidden to make basic choices about their lives. In 2016, the governor of North Carolina, Pat McCrory, signed into law a bill that makes it illegal for a transgender person to use a bathroom that is not in accordance with the gender on their birth certificate.

The new bill caused a backlash, including cancelled performances by artists ranging from violinist Itzhak Perlman to Bruce Springsteen. PayPal cancelled plans for a global operations centre in North Carolina, while US Attorney General Loretta Lynch, herself born in the state, described the legislation as 'state-sponsored discrimination against transgender individuals who simply seek to engage in the most private of functions in a place of safety and security'.

Meanwhile, in what one commenter described as 'the best selfie ever', Sarah McBride, LGBT communications manager at the Center for American Progress, posted a photograph of herself illegally in a women's bathroom. Her caption declared, 'They say I'm dangerous. And they say accepting me as the person I have fought my life to be seen as reflects the downfall of a once great nation.' McBride saw it differently: 'I'm just a person. We are all just people. Trying to pee in peace.'

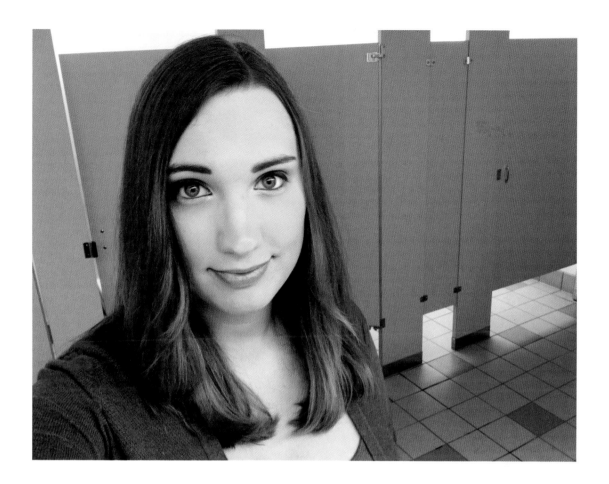

ABOVE: Sarah McBride posted this defiant selfie after North Carolina passed a bill making it illegal for her to enter a women's bathroom.

RIGHT: Some institutions decided enough was enough and came up with their own signs, pragmatically labelled neither Women nor Men, but 'Whichever'.

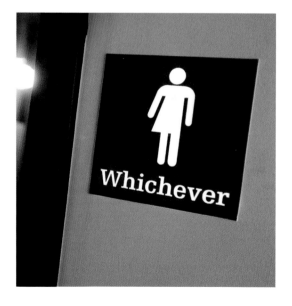

POWER TO THEIR ELBOW

'Nobody made a greater mistake than he who did nothing because he could only do a little.'
EDMUND BURKE

President Omar al-Bashir, wanted by the International Criminal Court for crimes against humanity and genocide, has ruled Sudan since 1989. He appears to believe he is undefeatable. During protests in 2012, al-Bashir mocked his critics, suggesting that they were 'licking their elbows' – a Sudanese phrase equivalent to 'pigs might fly' or 'in your dreams!'

The activist group Girifna ('We are fed up') turned the phrase around to give it power of its own. Thousands photographed themselves in contorted positions, attempting to lick their elbows, and a few agile Sudanese succeeded in doing so. Defiant joint-licking images were posted and shared online.

Today, al-Bashir is still in power, not least after gaining an alleged '94 per cent' of the vote in 2015 (the opposition boycotted the poll, widely seen as unfair). Still, when al-Bashir's rule finally comes to an end, elbow-licking may be seen as part of the mix that helped bring change.

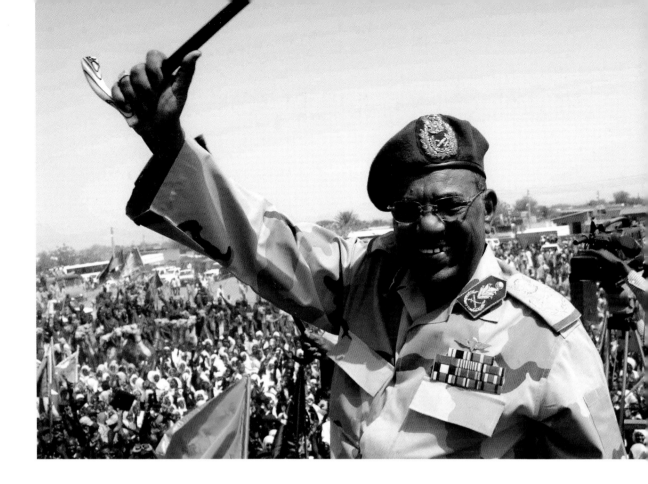

ABOVE: President Omar al-Bashir: in power for three decades; indicted at The Hague for genocide; won '94 per cent' of the vote in 2015; can't lick his elbow.

LEFT: A poster for a 'We can lick our elbows!' march in Sudan in June 2012 reads, 'We've come out, and there is no going back.'

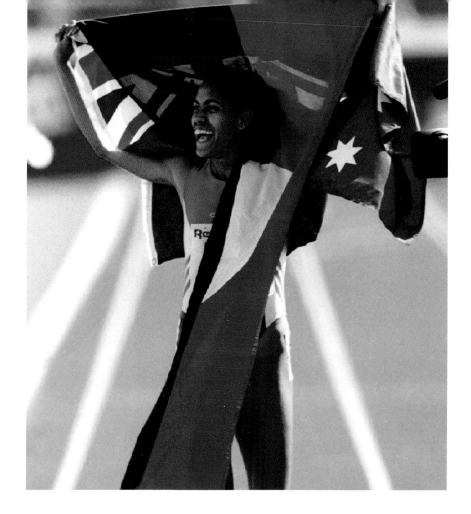

WAVING A DIFFERENT FLAG

Commonwealth Games, Canada, 1994. Cathy Freeman wins gold and breaks the rules by celebrating with the Aboriginal flag.

Cathy Freeman grew up with the prejudice that she and millions of Indigenous people had faced in Australia for many years. When she won her first running races at the age of ten, she received no medals. Medals went to white girls. Her own family history was marked by the suffering of what became known as the 'Stolen Generations', children forcibly removed from their families.

In 1994, aged twenty-one, Freeman became a national hero with her record-breaking 400-metre race for Australia at the Commonwealth Games. She decided her victory lap should be not just for her, but for all the Indigenous people of Australia. In defiance of the rules, she ran round the track with both the Australian and the Aboriginal flags.

'There is no greater sorrow on earth than the loss of one's native land.'

EURIPIDES

The head of the Australian team forbade her to repeat the action if she won the 200-metre race a few days later. Freeman did win. Again she wrapped herself in both flags. 'This was my race, and nobody was going to stop me telling the world how proud I was to be Aboriginal.' Freeman's defiance rocked Australia. She received thousands of letters. A ninety-four-year-old woman wrote, 'When I saw you run around with that flag, for the first time in my life I felt it was worth it all to be an Aborigine.'

Six years later, Freeman won gold again, at the Sydney Olympics in 2000. Before a jubilant home crowd, she repeated her victory lap wrapped in both flags. This time, there was no controversy. It was, as one commentator said, 'a moment that united a divided nation'.

The momentum grew for a national apology for the suffering of the Stolen Generations, which Freeman herself had pressed for. In 2008, the apology finally came. On behalf of the state, Prime Minister Kevin Rudd conceded the 'pain, suffering and hurt' of the past. The future would be based on 'mutual respect, mutual resolve and mutual responsibility'.

Freeman was photographed listening to the historic speech. As she listened, she wept. 'We will never forget,' she said. 'But this allows us to forgive.'

PERIODIC PRESSURES

BELOW: In response to his 'vicious' anti-abortion bill, Governor Mike Pence (who became Donald Trump's running mate in the 2016 presidential elections, after others reportedly balked at the offer) received unusually detailed gynaecological updates from the women in Indiana.

Governor Mike Pence of Indiana sounded proud when in 2016 he signed, with a prayer, an anti-abortion bill that was, in the words of one pro-choice organization, 'one of the most vicious omnibus anti-abortion bills the United States has ever seen'.

The bill forbade abortion even in cases of severe disability. A woman who miscarries at eight weeks would be required to have the blood and tissue buried or cremated by a funeral home. In theory, a woman could be in breach of the new law by not burying her menstrual blood each month.

The women of Indiana had had enough. A Facebook page, Periods for Pence, was created, including email and phone details for the governor's office. Women began phoning Pence's office, taking advantage of his apparently detailed interest in obstetric and gynaecological issues, to let him and his colleagues know about their menstrual cycle, and to avoid getting unwittingly into trouble. 'Hello, everything is flowing nicely this month, little heavier than normal,' one woman told Pence's office. Another reported that 'my vagina and I had an ah-ma-zing weekend'. A third said, 'I just wanted to inform the governor that things seem to be drying up today. No babies seem up in there. Okay?'

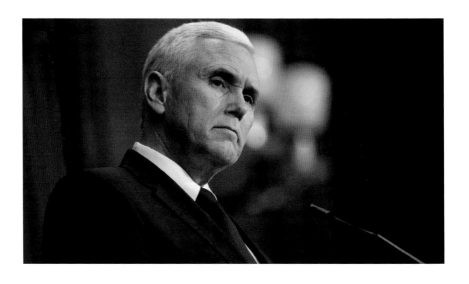

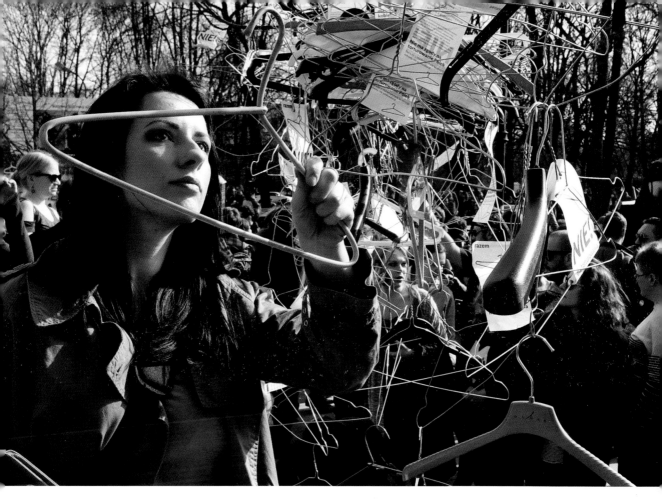

The stories multiplied – with serious implications, too. Planned Parenthood and the American Civil Liberties Union successfully challenged Indiana over what they argued was an unconstitutional bill.

In Poland, a proposed church-backed ban on abortion caused women to send equally graphic updates to the prime minister, along the lines of the action in Indiana. Many protested while waving coat hangers above their heads, a reminder of the dangerous abortions of the past. Describing a filmed mass walkout of women in response to a bishop's message read out in Polish churches in April 2016, the *Irish Times* wrote, 'The Middle Ages engaged in an unusual skirmish with the twenty-first century.'

ABOVE: Warsaw, Poland, April 2016. Women protested with coat hangers and staged mass walkouts from church.

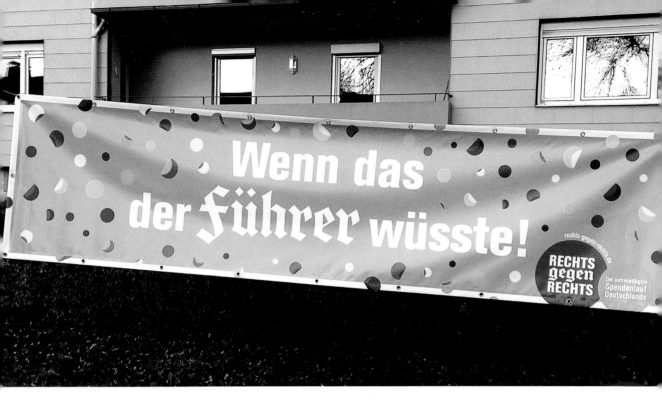

NEO-NAZIS RAISE MONEY FOR GOOD CAUSE

ABOVE: 'If only the Führer knew!' was the slogan that greeted neo-Nazis when they came to Wunsiedel.

In past years, neo-Nazis have enjoyed marching through the small German town of Wunsiedel, to the despair of those who live there. (Rudolf Hess, Hitler's deputy, was at one point buried in Wunsiedel, hence the pilgrimage.) In 2014, locals decided they had had enough of the unwanted intrusion.

The organization Right Against the Right, working with residents and local businesses, came up with a plan: for every metre that the neo-Nazis walked, locals would donate €10 to Exit Deutschland, an organization dedicated to helping neo-Nazis leave their toxic ideas behind and reintegrate into society. The further the neo-Nazis walked, the more money the marchers would raise for the anti-Nazi cause. Enthusiastic banners along the way proclaimed the news. The neo-Nazis could go ahead with the march – and thus raise money for combating the far right. Or they could abandon the march – an equally good outcome, from Wunsiedel's perspective.

The result: €10,000 to anti-neo-Nazism campaigns, and (in the words of the organizers) 'lots of startled far-rightists'. Marchers received a certificate, praising them for their 'outstanding achievement' in raising money for a good cause. The Wunsiedel action has been replicated in towns across Germany, helping to unsettle and keep the brownshirts down.

BELOW: 'Thank you for €2,500' was one of the slogans that far-right marchers passed on the road.

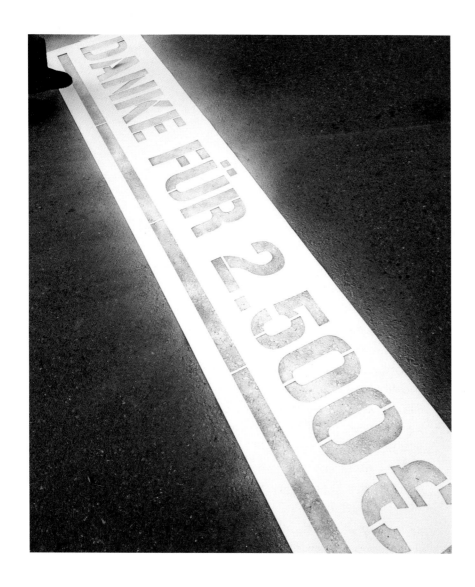

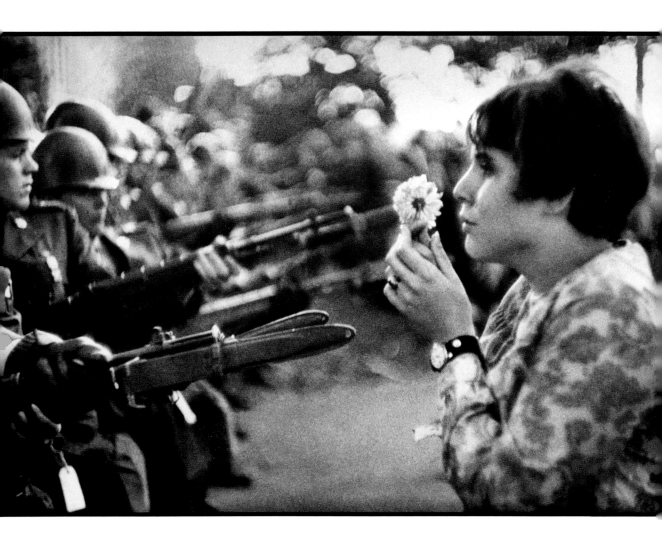

Washington DC,
21 October 1967.

THREE

..

Confronting Violence

Real or threatened violence has regularly been confronted or trumped by those who rely on the hidden power of non-violence.

In this famous photograph (opposite) – in a scene that has been endlessly repeated in different contexts – seventeen-year-old Jan Rose Kasmir stands with a flower before soldiers with bayonets at an anti-war protest in Washington in 1967. On that day, admittedly, non-violence was not a great success. Demonstrators were beaten, arrested and tear-gassed, even as they attempted to levitate the Pentagon. (Participants were instructed to perform 'a magic rite to exorcise the spirits of murder, violence and creephood'.)

But photographer Marc Riboud said he had the feeling that 'the soldiers were more afraid of [Jan Rose Kasmir] than she was of the bayonets'. Decades later, Kasmir's own memories expressed a similar thought. 'All of a sudden, I realized "them" was that soldier in front of me – a human being I could just as easily have been going out on a date with.'

Those who know they may be told to commit acts of violence against others are often unsettled when confronted by the non-violence of those they should beat or shoot. Like a real-life version of stone-paper-scissors, apparently vulnerable protests can prove surprisingly powerful.

MUSLIM GANDHI

'Given a just cause, capacity for endless suffering, and avoidance of violence, victory is certain.'
MOHANDAS GANDHI

The story of how Mohandas Gandhi, barefoot lawyer, confronted and humbled the British Empire is well known. Less remembered is the story of his close friend, Muslim leader Abdul Ghaffar Khan, also known as Badshah Khan or 'Frontier Gandhi'.

In 1929, Khan created an army of non-violence in the North-West Frontier Province, now part of Pakistan. The army became known as the 'Servants of God'. For Khan, the key weapon was 'patience and righteousness'. Those, he said, were 'a weapon that the police and the army will not be able to stand against'. His Servants of God became known as the Red Shirts, after the colour of their informal, dyed uniforms.

It is sometimes suggested that the British took a 'tolerant' approach to non-violent protest in India. The reality was different, as events in the Qissa Khwani Bazaar in Peshawar on 23 April 1930 made clear. Two weeks after Gandhi's defiance of the salt tax and famous march to the sea, Khan was arrested. Large crowds gathered in Peshawar, provincial capital of the North-West Frontier, demanding the release of Khan and others. Troops ordered the crowds to disperse. In the words of a report commissioned at the time by the All India Congress Committee, 'The people did not disperse and were prepared to receive the bullets and lay down their lives.' More than two hundred were killed that day. Some Indian soldiers disobeyed their British commander's orders, saying, 'You may blow us from your guns, if you like. We will not shoot our unarmed brethren.' Seventeen men were court-martialled and jailed for their disobedience.

The Congress Committee report noted, 'News of the Peshawar

incidents was withheld by the Government and only garbled versions were given to the public. Part of the truth leaked out, however … The courage, the patriotism, the non-violent spirit of the war-like Peshawaris became famous and earned for the whole province a unique place in the history of the struggle.'

As Khan himself wrote, in words that remain relevant in different contexts today, 'The British feared a non-violent Pathan more than a violent one. All the horrors the British perpetrated on the Pathans had only one purpose: to provoke them to violence.'

Khan's Red Shirts were not provoked. British rule ended. Khan died in 1988, aged ninety-eight. Two hundred thousand people attended his funeral.

Badshah Khan (fourth from left) stands next to his friend Gandhi, flanked by some of his non-violent Red Shirt army.

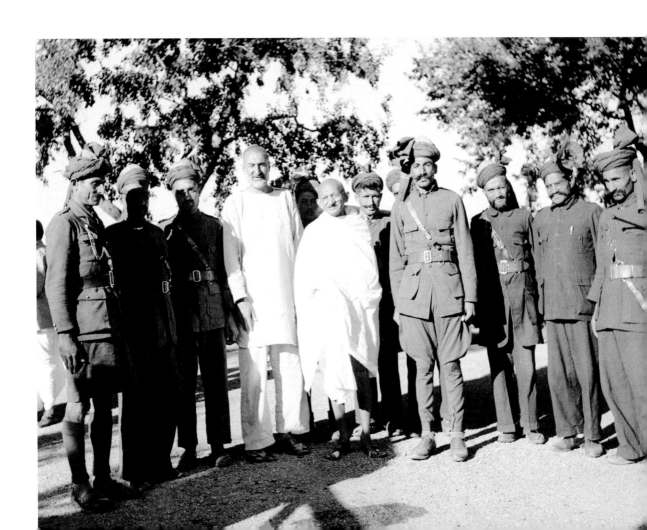

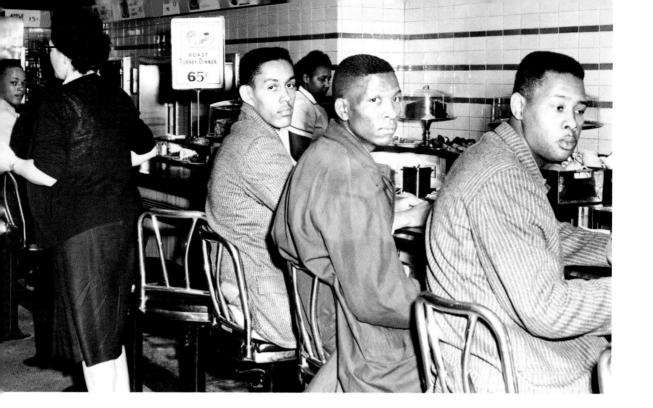

ARMED AGAINST VIOLENCE

In the American South in the 1950s, racism was not simply tolerated, it was violently enforced.

Some believed the obvious way to end violence was with more violence. For others, non-violence held the key. In 1959, twenty-two-year-old Diane Nash, a student at Fisk University, began attending non-violence workshops in Nashville, Tennessee. The sessions were organized by James Lawson, who had spent time in India and absorbed the lessons of Gandhi. The meetings took place in a Methodist chapel every Tuesday at 6.30 p.m. These workshops, and their participants, helped change America.

ABOVE: Nashville, Tennessee, February 1960. Protesters at a segregated lunch counter.

One participant later described the weekly scene, as they role-played with fellow activists acting as 'angry bystanders, calling us niggers, cursing in our faces, pushing and shoving us to the floor'. They learned never to respond to the violence with violence. Lawson insisted it was not enough simply to endure a beating or resist the urge to strike back. 'That urge can't *be* there,' he would say.

In February 1960, Nash and others launched their first challenge

when they sat down at segregated lunch counters in downtown Nashville. They were beaten. They were arrested. Others stepped forward to take their places. The pattern was repeated, over and over. Eighty-one protesters were arrested in a single day.

Lawson (described as a 'flannel-mouth agitator') was expelled from university. But, after a series of actions over three months that culminated in a historic exchange between Diane Nash and the city mayor, lunch-counter segregation ended. On 10 May 1960, downtown stores in Nashville served black customers at lunch counters for the first time.

It seemed – it was – a remarkable victory. But the essentials remained unchanged. The following year, Nash, as co-founder of the Student Nonviolent Coordinating Committee, played a key role in the Freedom Rides, challenging segregation on inter-state bus routes across the American South. Freedom Riders, black and white, faced attacks, jail and threats to their lives. Outside the town of Anniston, Alabama, the Ku Klux Klan firebombed a bus with Freedom Riders inside. Despite the attacks, the Freedom Riders, too, triumphed – which gave new impetus for further victories in the years to come.

Half a century later, Nash reflected on the risks she and others had taken. 'I sometimes wonder if we in the civil rights movement had left it to elected officials to desegregate restaurants and lunch counters, to desegregate buses … I wonder how long we would have had to wait. And I think, truly, that we might still be waiting.'

BELOW: May 1961. Freedom Riders travelling on buses into Mississippi.

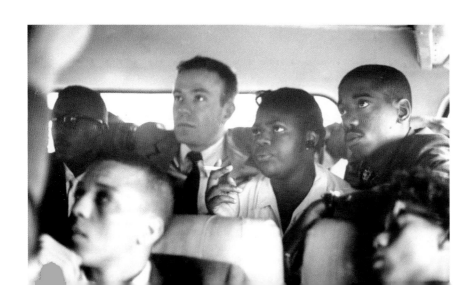

VALUING LIVES

On the evening of 26 February 2012, George Zimmerman was on a neighbourhood-watch patrol in a gated community in Sanford, Florida, when he saw a black teenager. He didn't like what he saw. He told the emergency dispatcher, 'These assholes, they always get away.'

Trayvon Martin, unarmed and aged seventeen, had just bought a bag of Skittles at the 7-Eleven store. Trayvon told a friend he was worried about the strange man following him. Moments later, Zimmerman shot Trayvon dead.

The police concluded there was nothing further to investigate, Zimmerman having displayed head injuries and claimed that he had acted in self-defence. The media showed no interest. It was another black man's death, and it looked set to be ignored. This time, though, things would end differently. Trayvon's parents launched a petition calling for justice. Gradually, then with dizzying speed, the Change.org petition gained momentum. At one point the petition was gaining a thousand signatures a minute, ultimately reaching more than two million. President Obama said, 'If I had a son, he'd look like Trayvon.' Zimmerman was charged with murder.

In July 2013, Zimmerman was acquitted on all charges. Yet again, that seemed to be the end of the matter. Again, it wasn't. On the evening of Zimmerman's acquittal, Alicia Garza was in a bar in Oakland, California. She composed a Facebook post (as she put it later, 'essentially a love note to black people'): 'I love you. I love us. Our lives matter.' Her friend Patrisse Cullors shared Garza's post, summing it up in a single hashtag: #blacklivesmatter.

And so it began. Garza, Cullors and a third friend, Opal Tometi, set up social media accounts that shared stories of why #blacklivesmatter. The slogan gained traction. Then, a year later, came Ferguson. Michael Brown, an unarmed eighteen-year-old, was shot dead by police in Ferguson, Missouri, in August 2014. Protests were violently dispersed. Black Lives Matter, the slogan that had begun with a Facebook post from Oakland a year earlier, went viral. Michael Brown was one of too many. Seventeen-year-old Laquan McDonald was shot and killed by police in Chicago.

Twelve-year-old Tamir Rice was killed by police while playing with a toy gun in Cleveland, Ohio. Twenty-five-year-old Freddie Gray died when his spine was severed in a police van in Baltimore, Maryland. And so on, many times over. The *Washington Post* calculated that unarmed young black men are seven times more likely than white men to die from police gunfire.

The Black Lives Matter campaign, and others like it, galvanized millions across the United States. Ferguson City Council agreed to the overhaul of police and courts that it had previously resisted. It was, Michael Brown's father told the mayor, 'beautiful, a good feeling'. In Chicago and Cleveland, voters threw out prosecutors who had failed to take action on police killings. Police officers have been charged and police chiefs have been fired. As the black American poet Langston Hughes had written ninety years earlier, 'I, too, am America.'

Baton Rouge, Louisiana, 9 July 2016. Ieshia Evans, a nurse from Pennsylvania, faces down armoured officers at a Black Lives Matter protest. After her arrest, Evans said, '[Baton Rouge] opened my eyes … I have been sleeping and now I'm awake.'

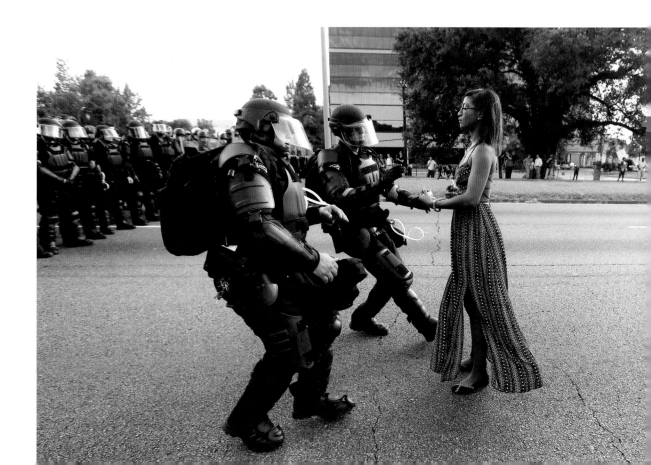

NUNS AND REVOLUTION

Under President Ferdinand Marcos, the Philippines was not an obvious place to imagine that non-violent opposition might succeed. Marcos's US-backed government tortured and killed its critics. Opposition leader Benigno Aquino was assassinated at the airport when he returned from exile to Manila in 1983. Marcos and his wife Imelda became known as 'the Macbeths of Manila'. Even some who supported non-violence suggested that armed rebellion might be needed because nothing else – surely – could work. Events proved otherwise.

After snap elections in February 1986, computer operators went public with their knowledge of electoral fraud. In the days that followed, millions took to the streets to demand that the election victory of Aquino's widow, Corazon Aquino, be honoured.

Nuns risked their lives as they knelt in front of tanks. Their courage became a key element of the non-violent juggernaut for change. As his core support crumbled, Marcos still sounded bullish. He declared, 'I have all the power in my hands to eliminate this rebellion at any time we think enough is enough. I am not bluffing … Let the blood fall on you.'

But it soon looked as if the president had been bluffing, after all. Eighteen days after the election, on 25 February 1986, Marcos stood beside his wife on a palace balcony as a tearful Imelda sang a final love song to a small crowd of remaining supporters. It was Imelda's favourite song, 'Because of You'. Then the couple fled to Hawaii.

Corazon Aquino became president. She described how 'a people knelt in the path of oncoming tanks and subdued with embraces of friendship the battle-hardened troops sent out to disperse them'. Aquino concluded, 'All the world wondered as they witnessed a people lift themselves from humiliation to the greatest pride.'

Manila, Philippines, February 1986. Sister Porferia Ocariza and Sister Teresita Burias kneel at the head of a crowd that stopped tanks. Sister Teresita said afterwards, 'It was very much a miracle.'

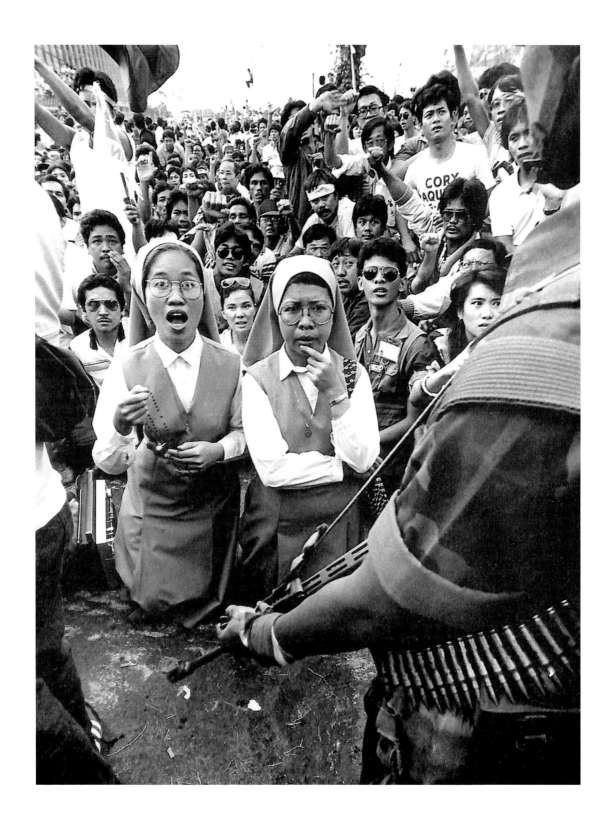

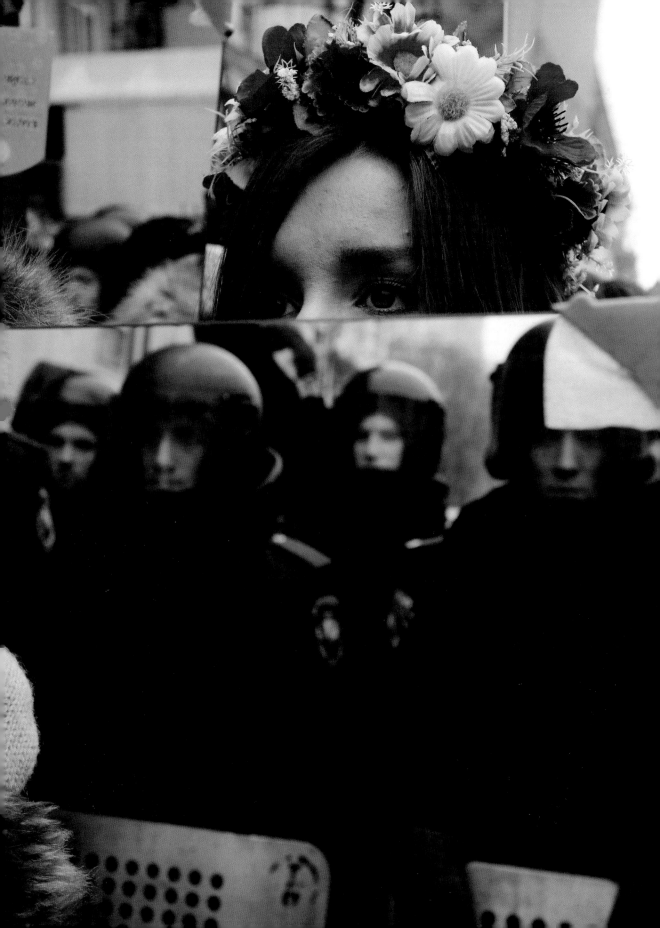

MIRROR IMAGE

In late 2013 and early 2014, huge crowds gathered in the centre of the Ukrainian capital, Kiev. The protests began over a change of policy by President Viktor Yanukovych, apparently as a result of pressure from Moscow. Yanukovych refused to sign a previously negotiated agreement that was set to bring closer ties between Ukraine and the European Union. The pro-European protests quickly broadened into a challenge to Yanukovych's rule. The riot police seemed ready to use unlimited violence against protesters in the central square, the Maidan. Before the protests were over, more than eighty people would be killed.

Even as the violence began, however, Ukrainians remained creative and unbowed. Women held up mirrors, forcing policemen with riot shields to confront their own image. The policemen, in turn, tried to avoid the direct gaze of the women who looked like their sisters, mothers or even grandmothers. 'It was tense at first; I was a little scared,' said Kateryna Maksym. 'But, like with mirrors, you have to show positive energy to have it reflected.'

On 21 February 2014, a day after dozens were killed in the most violent clashes of the 'Euro-Maidan' protests, many police defected to the protesters' side. It seems they had looked in the mirror and did not like what they saw.

Late that evening, Yanukovych fled. Crowds wandered in a daze around the president's opulent mansion, which included everything from an underground boxing ring to a private petting zoo. For Yanukovych, police defections had proved the final straw.

Kiev, Ukraine, December 2013. Women hold up mirrors to riot police. Police defections helped trigger the end of the regime.

THE INDIAN EXPRESS

New Delhi: June 28 1975

Economic notes

Blocked option

by Balraj Mehta

Bangladesh newspapers justify action

Letters

Emancipation of women

College teachers

Exams in U.P.

Rajasthan exams

Vocational training

Provident Fund

Freedom fighters

Railway casualness

Haryana Ministry hails emergency

Emergency for first time since freedom

Who is to blame?

'Insulting' Laotian note to US mission

States told to use all powers

TN to carry out instructions

Gold seized in Gonda raids

Delhi taken by surprise

Tito's message to Mrs Gandhi

No comment by Soviet paper

BBC's lead story

Sec 144 in Capital

Shiv Sena chief blames opposition

AIR refusal to Patel service

No newspapers

Timely step, says Congress lawyers

Eight Kashmir officials held

The *Indian Express*, 28 June 1975, after Prime Minister Indira Gandhi's declaration of a state of emergency and the imposition of wide-ranging censorship. This empty space became one of the most powerful editorials ever published in India.

FOUR

··

Making Truth Heard

Those who hold power often go to considerable lengths to prevent certain truths being heard. Equally, those who care about truth take extraordinary risks to ensure that truth will out.

Sometimes it's a matter of smuggling things past the censor – or publishing a giant white space to remind people of what the authorities *don't* want you to read. In the Ottoman Empire in the early twentieth century, cartoonists would seek the censor's approval for one cartoon, then erase it and substitute another – a trick that was partly repeated in Burma a century later.

Sometimes it's a question of ensuring difficult truths are spoken aloud – about climate change (when world leaders don't wish to listen), corporate arm-twisting (when the company itself tries to silence truth-tellers) or a murderous group (when criticism is so dangerous). Sometimes it's simply a case of ensuring that crimes are remembered, so that we learn lessons for the future. In all cases, truth matters.

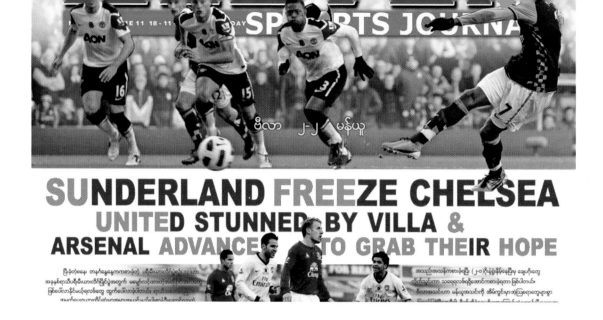

SUNDERLAND FREEZE CHELSEA
UNITED STUNNED BY VILLA &
ARSENAL ADVANCE TO GRAB THEIR HOPE

COLOUR IT IN

In 1962, the military seized power in Burma and ruled the country – later renamed as Myanmar – with an iron grip for the next half-century. Thousands were killed in pro-democracy protests in 1988. The party of Aung San Suu Kyi, daughter of Burma's national hero Aung San, gained electoral victory in 1990. Her reward was to be held under house arrest for most of the next twenty years.

These were dark times, but the Burmese did not give up hope for a different future. In 2007, Buddhist monks led huge street protests in what came to be known as the 'Saffron Revolution'. The junta – which called itself the State Peace and Development Council, despite offering neither peace nor development – repressed the protests violently.

Things had to change. In 2010, Aung San Suu Kyi was released. This was the most dramatic turnaround in Myanmar for many years, and was front-page news all around the world. But the government was reluctant to admit the momentousness of the event, which had implications for the future of the junta itself. Newspapers were ordered to bury the story of the release on the inside pages, as if it were mere routine.

A Burmese sports paper sidestepped the prohibition with creative deceit. *First Eleven* carried what appeared to be a series of headlines

about English football results. The censor's office received a black and white faxed copy of the proposed front page, and approved it without changes. Surely – the censor presumably reasoned – nothing could be controversial in a front-page headline that merely summarized the weekend's soccer games: 'Sunderland Freeze Chelsea, United Stunned by Villa, & Arsenal Advance to Grab Their Hope.'

News-stands the next day, however, revealed a different story. Printed in full colour, some of the letters could be seen to spell out a different message: 'Su [Aung San Suu Kyi] … Free … Unite … & … Advance … to Grab the … Hope.' Which was exactly what many Burmese proceeded to do.

The generals were furious; ordinary Burmese were delighted. Publication of the paper was suspended, but it was too late. The damage was done. All copies of the paper were sold out. The impertinent headline, reinforced by countless other protests all across Myanmar, helped pave the way for further moves towards democracy.

In parliamentary elections in 2015, Aung San Suu Kyi's party, long banned from politics, gained a majority. In 2016, Aung San Suu Kyi's friend and supporter Htin Kyaw became the country's president, thus ending more than half a century of military rule.

BELOW: Myanmar, 13 November 2010. Burmese opposition leader Aung San Suu Kyi is released after almost twenty years of house arrest.

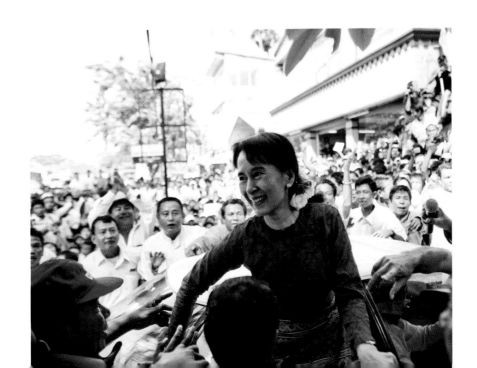

WATER PRESSURE

Man-made climate change is the greatest danger to our planet today. If left unchecked, the effects will – in the words of the UN's Intergovernmental Panel on Climate Change – be 'severe, pervasive and irreversible'. These facts are well known. Despite this, however, politicians have been reluctant to act or have energetically sought to pass the responsibility on to others.

Those who will be most drastically affected by climate change include the populations of many of the world's small islands. The Maldives, in the Indian Ocean, lie just a few feet above sea level. The islands risk being obliterated if oceans rise.

Mohammed Nasheed, environmental and human rights activist, became president after the country's first multi-party elections in 2008. He wanted to confront the refusal by world leaders to address the issues. Nasheed decided to hold a government cabinet meeting underwater in full scuba gear. The ministers spent half an hour on the seabed, after first practising slow breathing. They communicated with whiteboards and hand signals. When the cabinet meeting was over, Nasheed gave an underwater press conference, another presidential first. 'If the Maldives cannot be saved today,' he told journalists, 'we do not feel that there is much of a chance for the rest of the world.'

Today, Nasheed is no longer his country's president. In 2012, he

In October 2009, President Mohammed Nasheed of the Maldives goes underwater to make his point.

was forced out of office – at gunpoint, according to his own account. In 2015, he was convicted of 'terrorism' and jailed after a trial that was widely condemned. (In 2016, he was granted political asylum in the UK.)

But Nasheed's underwater wake-up call – reinforced by many other protest actions, worldwide – has begun to have the impact he dreamed of. A petition of two million signatures was delivered to the UN Secretary-General, Ban Ki-moon. In 2015, world leaders in Paris finally agreed on action. Kumi Naidoo, director of the environmental group Greenpeace, said, 'The wheel of climate change turns slowly, but in Paris it has turned.'

GOING BANANAS

Those with deep pockets and access to expensive lawyers tend to believe that, if you throw enough money at a problem, critics can always be silenced. But sometimes it doesn't work that way, as Dole, the world's largest fruit company, discovered in recent years.

In 2009, Swedish film-maker Fredrik Gertten and his colleagues released *Bananas!**, a film that told the story of twelve Nicaraguan fruit workers and a lawyer working on their behalf. The banana workers were suing Dole in connection with alleged damage to their health from pesticide use. The film was selected for competition at the Los Angeles Film Festival. But then, strange things started to happen. Dole demanded that the film should be withdrawn because of its 'glaringly false' statements. (Dole had not seen the film at that point.)

The *Los Angeles Business Journal* published a front-page article, 'The Big Slip-Up', accusing the film-makers of failing to check their facts. (The reporter had not watched *Bananas!**, nor had she spoken to the film-makers before writing her story.) Festival organizers bowed to the pressure and removed the film from competition.

It seemed the film-makers had lost before legal action even started. Dole executive vice-president Michael Carter told a Swedish newspaper, 'Let [Gertten] fight. He will definitely lose.' But the film-makers' powerlessness became a kind of power when Gertten continued to film the entire process – lawsuits, bullying, PR spin – in the weeks and months that followed.

Dole's PR company quoted Nietzsche: 'It is easier to cope with a bad conscience than a bad reputation.' But Dole's trashing of Gertten's reputation backfired. Dole wrote to members of the Swedish parliament, warning them against the 'false, defamatory and irresponsible' film. The Swedes were unimpressed. A parliamentary showing of the film was packed out, and the two MPs who had organized the showing – one Social Democrat, one Conservative – wrote to inform Dole that the company had a 'poor understanding' of Sweden's two-hundred-year tradition of free speech. Engaging in debate, they suggested, would have been more appropriate. Finally,

Cropdusting a plantation in Nicaragua – as seen in the documentary *Bananas!**, about pesticides and health.

Dole began to back down. The company offered to drop its lawsuit if Gertten would merely agree to cut parts of the film. Gertten did not agree. In November 2010, eighteen months after the action began, a Los Angeles court found that 'careful review' of *Bananas!** 'did not support' Dole's assertions. Dole was ordered to pay $200,000 in legal costs.

*Bananas!** was shown in eighty countries, and won awards around the world. In Sweden, disgust at Dole's behaviour contributed to a sixfold rise in the sales of fair-trade bananas. Meanwhile, Gertten's footage of the pressures on him to stay silent became the subject of a follow-up documentary, *Big Boys Gone Bananas!**, released in 2012. One review of the film concluded, 'Corporate PR has seldom looked so sinister, or daft.'

SITTING IT OUT

**'Silence encourages the tormentor,
never the tormented.'**
ELIE WIESEL

Sarajevo, Bosnia,
6 April 2012.
Each of the
11,541 red chairs
commemorated
one of the victims
of the city's three-
year siege that
began twenty
years earlier.

The war in Bosnia lasted for three years from 1992 to 1995. The Bosnian capital, Sarajevo, was besieged for most of that time. Across the country, tens of thousands of civilians were killed. The country suffered ethnic cleansing, rape and genocide.

Interviewing Serb leaders at that time could be a strange experience. When I asked Slobodan Milošević, Serb leader and chief instigator of the conflict, if he might one day find himself before a war crimes tribunal, he sounded surprised and explained that he was 'for peace'. Radovan Karadžić, leader of the Bosnian Serbs, assured me there were no snipers surrounding the capital – cheerfully denying the lethal reality that Sarajevo experienced every day.

Too often, basic facts get lost. Humanity can get lost, too. But Sarajevo was determined to ensure that humanity and truth were not forgotten. In 2012, on the twentieth anniversary of the outbreak

of the war, 11,541 empty red chairs were laid out in eight hundred rows for half a mile along the main street of the city, representing all Sarajevans who had died in the war. They included 643 smaller chairs. Those represented the children who died.

During and after the conflict, it seemed that Milošević and Karadžić were right to be complacent. There appeared to be little prospect that they would ever be held to account. But justice can be patient. In 2001, six years after the conflict ended, Milošević was sent to The Hague, and died behind bars. Karadžić, who lived for years under cover as an alternative healer and expert on 'human quantum energy', was arrested in 2008. In 2016, he was found guilty of crimes against humanity and genocide, and jailed for forty years.

TRAITOR TO HERO

In Algeria's war of independence, which lasted from 1954 to 1962, torture by French forces was routine. A French paratrooper, who himself committed torture, remembered later, 'All day, through the floorboards we heard their hoarse cries, like those of animals being slowly put to death. Sometimes, I think I can still hear them.' Suspects were frequently tortured to death. General Jacques Massu said, 'In answer to the question: "Was there really torture?" I can only reply in the affirmative … I am not frightened of the word.'

This was all done in order, allegedly, to improve the security situation – the same arguments that would be heard in the twenty-first century when US officials also argued that basic rules no longer applied. In the words of the CIA Director of Counterterrorism, Cofer Black, 'After 9/11, the gloves came off.' That was the context surrounding US torture in Abu Ghraib prison in Baghdad and elsewhere.

In Algeria, one man broke what he called 'the sordid conspiracy of silence'. Jacques Pâris de Bollardière was France's youngest general, highly decorated for his courage in the Second World War. He was sickened by what he had seen, and by the fact that his colleagues were so eager to defend torture. In 1957, he asked to be released from his command. He warned publicly of the 'terrible danger if we were to lose sight, under the fallacious pretext of immediate effectiveness, of moral values'. That wasn't what the government wanted to hear. De Bollardière was jailed in a military fortress for sixty days. By contrast, General Massu was promoted.

Twenty years after de Bollardière's death, France finally began to honour his stance. A square in Paris is named after him. He is officially praised for his moral courage – the same courage for which he was rebuked and punished at the time. In the US, meanwhile, those who maintained their integrity in dark times – like General Alberto Mora, who spoke out against the greenlighting of torture at Guantánamo Bay and elsewhere – have still not received the official recognition they deserve.

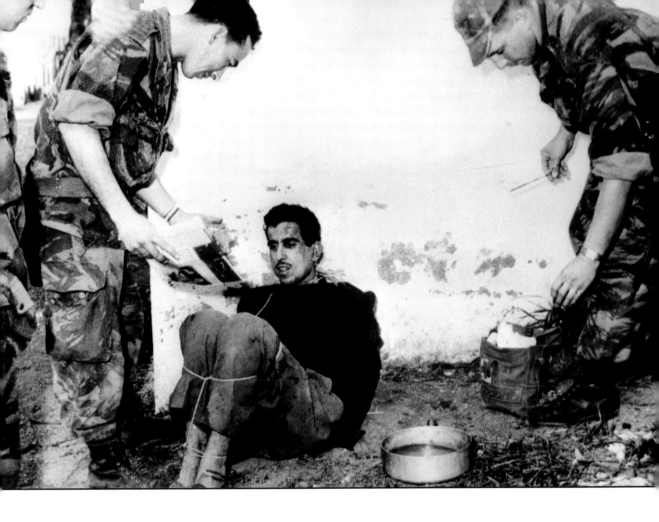

RIGHT: General Jacques Pâris de Bollardière spoke out against torture, and suffered the consequences. Today, his moral courage in defying his superiors is honoured.

LIFTING THE LID

'The authority of government, even such as I am willing to submit to … is still an impure one: to be strictly just, it must have the sanction and consent of the governed.'

HENRY DAVID THOREAU

Nothing in Edward Snowden's background suggested anything radical. His grandfather was a rear admiral, his father a coastguard. Snowden tried to enlist for Iraq before joining the CIA as a systems analyst, where he was an acknowledged IT wizard.

In 2013, he became arguably the most important whistleblower in history. He risked everything to reveal blanket surveillance by the US government, helped by the UK. He showed the world how electronic eavesdropping had spiralled out of all control.

For Snowden, a tipping point was watching James Clapper, Director of National Intelligence, lie under oath to Congress. Asked whether the government collected data on millions or hundreds of millions of Americans, Clapper replied, 'No, sir. Not wittingly.' The truthful answer would have been, 'Yes, sir. Wittingly.' Clapper's lies were, said Snowden, 'evidence of a subverted democracy'. With a nod to Thoreau, whose *Civil Disobedience* was published in 1849, Snowden concluded, 'The consent of the governed is not consent if it is not informed.'

Snowden's revelations were published in the *Guardian* in London and around the world. He received a string of awards for his courage. The European Parliament praised him as a whistleblower and human rights defender. But those who wanted the trampling of citizens' privacy to remain a secret did not see it that way. Snowden tried to fly from Hong Kong to Latin America. His passport was cancelled mid-air, leaving him stranded in transit in Moscow. He was charged in absentia with espionage.

In the meantime, the British government demanded that the *Guardian* destroy all its copies of the Snowden files. Intelligence officials supervised a three-hour orgy of computer destruction in the *Guardian* basement, with the help of angle grinders and electric drills. As the *Guardian*'s editors had already pointed out, the paper still could (and would) access and publish material in the United States. But the British authorities were determined to follow through with their ritual, almost as if the internet had never been invented. The ceremonial destruction of the hard drive was, as one columnist noted, 'the most bizarre act of state censorship in the internet age'.

The US government has been equally inflexible. The *New York Times* suggested that President Obama should 'tell his aides to start finding a way to end Mr Snowden's vilification and give him an incentive to return home'. That didn't happen.

Snowden has no regrets: 'I don't lose sleep because I've done what I felt I needed to do; it was the right thing to do and I'm not going to be afraid.'

London, 20 July 2013. The British government – seemingly oblivious to the twenty-first century – ordered the *Guardian* newspaper to destroy hard drives and memory cards that contained information leaked by Edward Snowden.

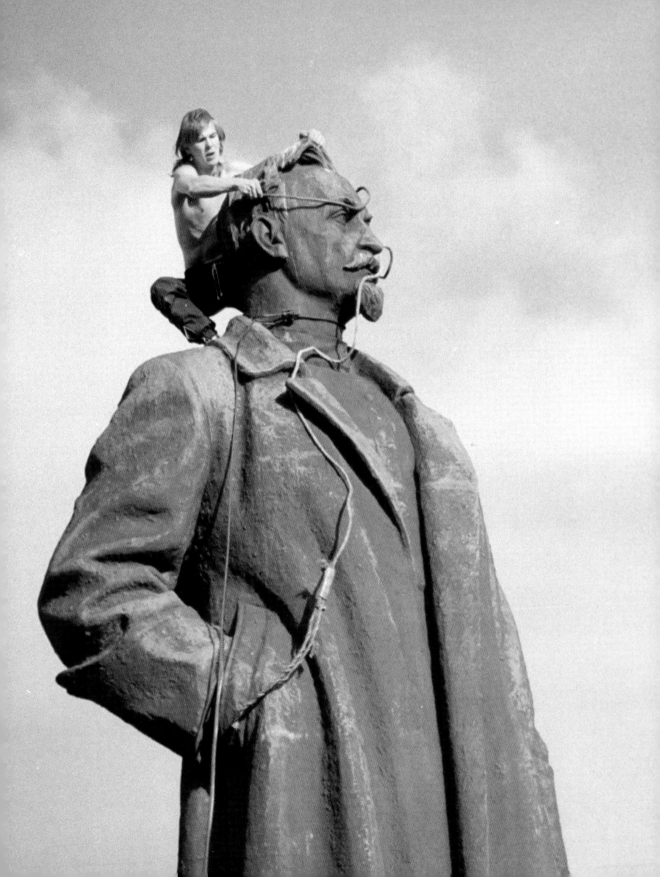

FIVE

..

Against
All Odds

There is every reason to think that the coup will succeed …
The indignation of the people on the streets counts for nothing.
(Edward Pearce, columnist, *Guardian*, 21 August 1991)

Scepticism is in many respects both admirable and desirable. We should question our own actions and attitudes. We should question the motives and actions of others. Sometimes, however, self-described 'realists' are too eager to underestimate the change that can be achieved, and to dismiss those who take risks for change.

Moscow, Russia, August 1991. A statue of Felix Dzerzhinsky, founder of the Soviet secret police, is toppled by protesters after the collapse of a hardline coup that lasted just three days.

The analysis of the Soviet hardline coup quoted above, with the writer's scornful judgement that defiance on the streets of Moscow 'counts for nothing', was demonstrably wrong. The collapse of the coup in response to popular protest, on the very day that those words were published, made that clear. In reality, as I had noted in an article written six months earlier, growing popular anger meant that 'the Kremlin cannot put the lid back on'. As a Russian commentator wrote at that time, 'Hundreds and thousands of bottles have been opened in the last six years, and their genies couldn't be enticed back inside or sealed up any more.'

Scepticism was, however, widespread among those who believed the popular mood to be irrelevant. Politicians are often keen for 'stability' not to be upset. But 'stability' in an authoritarian context is often anything but. Rights bring stability, repression doesn't.

AGAINST VANISHING

In 1976, a military junta seized power in Argentina. During what would come to be known as the 'Dirty War' – officially, the Process of National Reorganization – tens of thousands became 'the disappeared', a newly coined, lethal noun. Many abductees were dropped from planes into the ocean. Relatives were told that the whereabouts of their loved ones was 'unknown'.

On 30 April 1977, fourteen women came together in the Plaza de Mayo, near the presidential palace in Buenos Aires, demanding change. They wanted information about their children, kidnapped by security forces off the streets or from their homes.

At first, the women were ignored. But they and others like them helped change the country. Every Thursday at 3.30 p.m. the women came together – more and more of them as the months went by. The police told them to 'circulate', or move on. So they did – in slow circles around the square. They were dismissed as *las locas*, 'the crazy women'. As one of their number, Aida de Suarez, later noted, 'We went to the streets to confront them directly. We were mad. But it was the only way to stay sane.'

The Mothers of the Plaza de Mayo were tortured. Some, like Azucena Villaflor, were abducted and killed. But still the Mothers continued their work. De Suarez said, 'They thought that by kidnapping Azucena, by kidnapping the fourteen Mothers, they would destroy our movement. They didn't realize this would only strengthen our determination.' Hundreds took part in the protests each week. Each woman wore a white headscarf, often bearing the name of a loved one. As the Mothers gained global recognition, the junta decided that they were no longer just crazies. They were paid the compliment of being judged 'as subversive as their children'.

In 1983, the junta finally gave way to pressures for civilian rule, but the Mothers and the Grandmothers of the Plaza de Mayo continued to campaign for justice. In 2005, Azucena Villaflor's ashes were buried with honour in the Plaza. In 2011, Alfredo Astiz, one of the most feared agents of the junta, who was directly responsible for the abduction of Villaflor and others, was jailed for life. Junta leaders

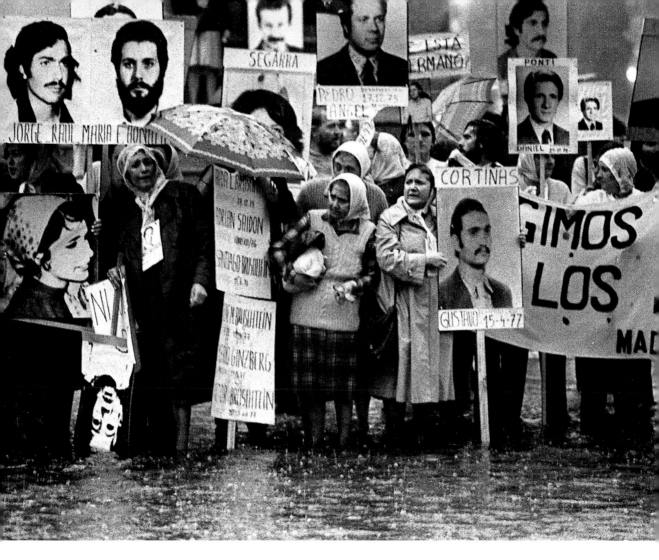

were also jailed. Finally, justice had been achieved.

Estela de Carlotto, one of the Grandmothers of the Plaza, had been searching for her unknown grandson since he had been born in captivity to her daughter Laura and taken from her before she was killed. De Carlotto insisted she would find him one day. It seemed impossible. In 2014, de Carlotto found her grandson Ignacio. She had waited for that moment for thirty-six years.

From 1977, the Mothers of the Plaza de Mayo repeatedly defied the military junta in Argentina by publicly demanding the truth about their children, who had been 'disappeared'.

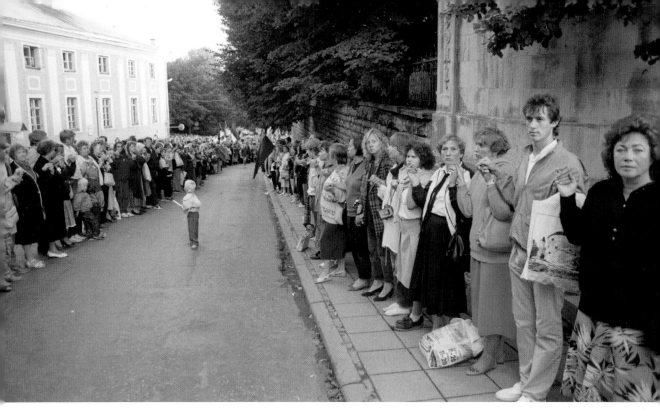

CHAIN REACTIONS

Estonia, 23 August 1989. Two million people took part in a 400-mile human chain. They demanded truth and the restoration of sovereignty.

In 1989, peaceful protests ended one-party regimes throughout Eastern Europe. In the Soviet Union, much less had changed. Lies were still told about injustices that stretched back half a century.

Under the secret terms of the 1939 Molotov-Ribbentrop pact, Hitler and Stalin had agreed to divide up much of the region. Hitler took most of Poland, and gave the three Baltic states – Estonia, Latvia and Lithuania – to Moscow. After 1945, when Hitler's armies were driven out of Russia, the annexation was never reversed. During the 1940s, hundreds of thousands of Balts were deported to Siberia and elsewhere.

But Balts never fully accepted the loss of independence. By 1988, people were making their voices heard. Massed choirs at an Estonian song festival helped bring change, in what became known as the country's 'Singing Revolution'. The authorities had to ask themselves, how do you arrest an entire stadium for singing forbidden songs?

In 1989, Balts were determined that the truth about history – how

Stalin had destroyed their sovereignty, and deported and murdered so many – should finally be heard. On the fiftieth anniversary of the Nazi-Soviet pact, two million people – a third of the population – took part in a 400-mile human chain across the three Baltic republics. The Kremlin threatened dire consequences, declaring, 'People should know the abyss into which they are being pushed.'

The Balts refused to back down. Instead, they publicly reasserted their long-lost sovereignty. When I asked about the possibility of tanks coming in, one Estonian leader told me – rightly, as would later become clear – that any crackdown would only be the dragon's dying gasp.

In January 1991, Russia launched its long-threatened crackdown. Soviet troops killed protesters defending the parliament in Lithuania. In neighbouring Latvia, crowds risked their lives as they partied, while waiting for more Kremlin violence. Outside the cathedral in Riga, I talked to Privite and her forester husband as they cheerfully waltzed round to the sound of a brass band. In a corner of the cathedral, doctors and nurses sat in an improvised operating theatre, waiting for the casualties. Privite explained, 'My children are all grown up. And I'm not afraid for myself. Why should I be?' Lia, a sixty-seven-year-old cleaner, agreed: 'All my family were in Siberia. Things will be bad now – but I think we will be independent. Even if I die, I want my children to see it.'

Seven months later, the defeat of a hardline coup triggered the collapse of the Soviet Union itself. The Balts regained their independence and the truth about history could be freely told. The actions of Privite, Lia and millions of participants in a vast human chain all played their part.

HAIRCUTS AND DICTATORS

'Our assessment is that the Egyptian government is stable.'

US SECRETARY OF STATE HILLARY CLINTON, 25 JANUARY 2011

'I really consider President and Mrs Mubarak to be friends of my family,' Hillary Clinton told an interviewer in 2009. When pressed on human rights abuses in Egypt, she seemed reluctant to speak uncomfortable truths. 'We all have room for improvement,' was all that the US Secretary of State was ready to concede. Millions of Egyptians felt that Clinton's response – in effect, 'Nobody's perfect!' – did not begin to reflect the reality of Mubarak's long, corrupt and brutal rule.

The murder a year later of twenty-eight-year-old Khaled Said, dragged out of a Cairo internet café by security forces and battered to death in the street, became a focus of huge popular anger. Images from the morgue of his smashed face went viral. A Facebook group, We Are All Khaled Said, created anonymously by Google marketing executive Wael Ghonim, gained hundreds of thousands of members, and energized the protests that began seven months later, on 25 January 2011, in Cairo and across Egypt.

Despite the violence unleashed by the authorities in the days that followed, in which more than 800 people died and thousands were injured, the protesters on Tahrir Square and elsewhere remained overwhelmingly peaceful. Ramy Essam, an engineering student, composed the song 'Leave!', whose message became the anthem of the Square:

Cairo, Egypt,
11 February 2011.
Courage, music
and humour
helped make this
day come.

Leave, leave, leave!
He will leave, because we won't leave!

Egyptian humour repeatedly riffed on the 'Leave!' theme. One man carried a placard linking his own domestic situation to the urgent need for Mubarak to go: 'Please leave. I got married recently. I miss my wife.' An unkempt demonstrator insisted, 'Please leave. I need a haircut.' A third held a placard patiently over his head. His slogan summed up his dilemma: 'Please leave. My arm hurts.'

On 10 February, President Mubarak announced he would not yet leave, but would 'continue to shoulder' his responsibilities. The crowds became angrier still. Finally, just after 6 p.m. on 11 February 2011 – after eighteen days of growing protests – the vice-president announced that Mubarak was indeed leaving. Tahrir Square erupted in celebration. A popular anthem, 'The Sound of Freedom', declared:

> *We broke all boundaries.*
> *Our weapon was our dreams.*

RAP AGAINST
INHUMANITY

ABOVE, LEFT:
From El General,
who helped
end repression
in Tunisia, to
defiance against
Islamic State
today, rap music
has played its
role.

ABOVE, RIGHT:
Raqqa in eastern
Syria, declared
by Islamic State
as its capital.

In Tunisia and across the Middle East, music played a key role in the uprisings of 2011. 'Rais Lebled', by Tunisian rapper El General ('Mr President, your people are dead / People eat from the garbage / Look what's happening in your country') became a hit with Tunisian and Egyptian protesters alike.

When Zine al-Abidine Ben Ali, president for twenty-three years, fled to Saudi Arabia in January 2011, his departure and the democratic elections that followed seemed to pave the way for a new era. But even as Tunisia tried to rebuild, it has been plagued by new violence. In two separate attacks in 2015, twenty-two people were killed in the National Bardo Museum in Tunis, and thirty-eight died in an attack in the beach resort of Sousse. So-called Islamic State – ISIS, ISIL, Daesh, call the murderous group whatever name you like – claimed responsibility for both atrocities.

Rap music, which played an important role in confronting corrupt governments in past years, now challenges the brutality of Islamic State and Al Qaeda, too. Mehdi Akkari, 'DJ Costa', has used his music to speak out against Daesh not least after his own brother travelled to join the terror group in Syria. One of his songs is 'Brainwashing':

They prey on your heart and your sentiments
They say come support the brothers who are being tortured
Every time death is near you, you're a step closer to paradise.

But, sings DJ Costa, 'Think about it, why are they coming after you?'

DJ Costa has repeatedly been threatened, and survived an apparent assassination attempt. He insists he will not stop. 'Terrorism is my enemy. And a rapper who doesn't defend his people is not a rapper.'

Across the region, people take remarkable risks to defy ISIS. The citizen journalists of Raqqa Is Being Slaughtered Silently document the stark reality of life inside the declared capital of Daesh in eastern Syria – a town that used to be, as one of the Raqqa group points out, 'a normal city, like any city in the world'. The members of Raqqa Is Being Slaughtered Silently work in extraordinarily dangerous circumstances, but continue regardless.

In Beirut, meanwhile, the Great Departed band sing darkly satirical songs that mock and confront Daesh, with lines like, 'And because Islam is merciful, we shall butcher and hand out meat. And because we need to reduce traffic, we will blow up human beings.'

The risks for all of the above are obvious. A member of Raqqa Is Being Slaughtered Silently argues, 'By the fact that we are staying alive, we are hurting ISIS.' For them and others, it is impossible not to confront ISIS, as they look to the future and hope for a time when – not least because of the courage of the Raqqa group themselves – the fear of Islamic State will be a thing of the past, in Syria, Iraq and towns and cities around the world.

DARTH SAVES THE WORLD

For twenty years, Amnesty International, Oxfam and others around the world campaigned for a global arms trade treaty that would ban the sale of arms to those who might use those weapons to commit atrocities. But governments were less than keen, not least because the global arms industry is worth $100 billion a year.

When campaigners first presented the idea, they were told it was 'utopian'. Officials insisted, 'You will never succeed.' Over the years, however, millions pressed for change. Gradually, barriers were broken down – through individual and mass actions, new and old media, quiet and megaphone diplomacy. In reaching the endgame, campaigners found some surprising allies.

One day in June 2012, a vast stretch limousine with darkened glass drew up outside the factory of the Belgian machine-gun manufacturer FN Herstal. Herstal confirmed to the chauffeur that yes, this was the right place for his boss to come and buy guns. But then – out of the car stepped the boss himself.

The boss turned out to be Darth Vader. Suddenly, Herstal changed its mind: 'Not him, no. We're not going to sell you weapons. We're calling the police!'

Belgium, June 2012. Darth Vader visits the factory of Belgian arms manufacturer FN Herstal – and highlights poor regulation of arms sales.

At the Dassault plant in France, where the Joker emerged from his sports car to buy weapons, it was the same story. The Joker was incredulous: 'But you sell weapons to everybody, you don't ask questions. Why can't *I* buy weapons?' As the Joker himself pointed out, his credentials were excellent: 'I'm a bad guy!'

The videos of the two visits, organized and filmed by Amnesty International, highlighted an obvious truth: new rules were needed, so that it would no longer be legal to sell weapons to tyrannical regimes. Why should Darth Vader and the Joker be the only bad guys who aren't allowed to buy arms?

The campaign stunts caused official embarrassment and increased the momentum for change. A year after those visits by the bad guys, governments adopted an Arms Trade Treaty at the United Nations. Persuading governments to comply with the treaty they have signed up for is the next important step. Maybe Darth and the Joker are still needed.

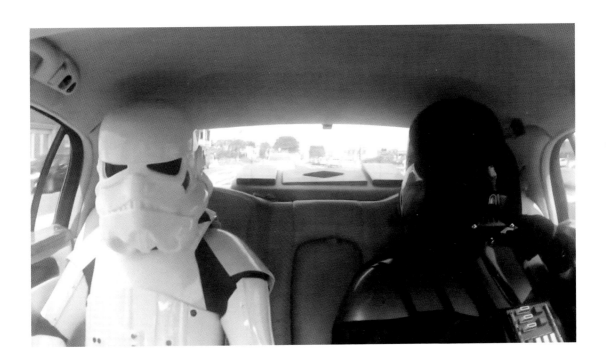

SIX

..

Art and Defiance

Art, theatre, music and cinema are fertile areas for defying authority around the world.

Theatre provides obvious possibilities for sly parallels with reality, even where the truth cannot be spoken directly. And it is not just contemporary theatre that has the power to offend. *Hamlet* and *Macbeth* regularly incur the censors' anger because four-hundred-year-old storylines of informers, palace coups and political murder seem so dangerously relevant.

Music, too, provides many opportunities for rebellion. In Chile, the military junta murdered the singer Víctor Jara in 1973 in retribution for the power of his music; the stadium where Jara and others died is now named after him.

Visual and performance art challenge the authorities in ways that may mean real risks for the artist, too. Cinema smuggles hidden messages past the censor, in oblique but unmistakable ways. Cartoonists tell the truth about the reality around them – whatever the cost of that truth-telling may be.

The ways that authorities crack down on artists can be seen as an indirect tribute to the power of their work. Art is neither political nor apolitical. Art is life itself – which encompasses everything around us, including the ways we are ruled or misruled.

SUBVERSIVE CRABS

The Chinese authorities are often unhappy about acts of defiance by the artist Ai Weiwei. In November 2010, they ordered the demolition of his new studio in Shanghai, the construction of which they had originally encouraged and approved but were now claiming had not followed planning procedures. Ai Weiwei responded by announcing a party to 'celebrate' the demolition.

The artist was promptly (again) put under house arrest to prevent him from attending. It seemed that the party could not go ahead. But hundreds turned up despite Ai Weiwei's absence. A banquet was served at long tables. On the menu were ten thousand river crabs.

Ai Weiwei's *He Xie* (2010) consists of thousands of porcelain river crabs. 'He xie' sounds like both 'river crab' and 'harmonization'. The title (and subject) refers to censorship, even while sidestepping it.

River crab is a Chinese delicacy, but Ai Weiwei's choice for his guests also had political significance, derived from a play on words. The Chinese word for 'river crab' sounds similar to the word for 'harmonization'. Harmonization, in turn, is a common synonym for censorship. As the crabs were served, banquet guests started to chant, 'For a harmonized society – eat river crabs!'

One guest pointed out that the river crab/censorship overlap created a dilemma for the authorities: 'Will river crab become a banned food in China? And would consuming this delicacy mean that you hold subversive intent against the authorities?' Ai Weiwei himself devised an artistic response to the destruction of his studio – with the creation of three thousand porcelain river crabs. The harmonizers and censors were both neutralized and immortalized.

LIFE-CHANGING HUG

General Francisco Franco (official title: 'Leader of Spain, by the grace of God') died in 1975 at the age of eighty-two, after thirty-six years of authoritarian rule. Even after the dictator's death, however, Spain did not instantly achieve democracy. Franco's supporters remained powerful and were ready to use violence to uphold the repressive status quo. One painting became a symbol of the democratic transition that Spain eventually achieved.

In 1976, the Democratic Committee commissioned from the artist Juan Genovés a poster demanding freedom for political prisoners. Genovés painted 'El Abrazo' ('The Embrace'), which depicted men and women hugging each other in joy and anguish after a long separation. When Genovés was at the printers, he was arrested for producing the powerful image. The authorities ordered all twenty-five thousand copies to be pulped. Genovés was jailed. He said later, 'For somebody who has not lived through those times, it is impossible to imagine that one might go to prison for painting a picture of people hugging. But that's how it was in those days.'

Democratic change continued, despite the repression. The painting gained terrible fame when armed men from the Apostolic Anti-Communist Alliance burst into a lawyers' meeting on Atocha Street in Madrid in January 1977. They didn't find the man they were looking for – so, instead, they stood a group of lawyers up against the wall and shot them. Five were killed, four more were injured. A poster of 'El Abrazo' hanging on the wall was spattered with the murdered men's blood.

That deadly attack became a last gasp for those who remained loyal to the old regime. One hundred thousand people attended the lawyers' funeral. Two months after the Atocha massacre, a new law was passed that led to multi-party elections the same year, the first since 1936. Half a million copies of the poster were printed. Proceeds from the sale were used to set up the Spanish branch of Amnesty International.

The image of 'El Abrazo' travelled the world. It had particular impact in Latin America, which suffered in the 1970s and 1980s from

military dictatorship and forced disappearances. In 2016, forty years after its creation, 'El Abrazo' was put on permanent display in the Spanish parliament, 'to serve as guide and inspiration'. Genovés said, 'The painting no longer belongs to me, its image belongs to the world.'

Spain, 1976.
'El Abrazo'
('The Embrace'),
by Juan Genovés
demands
freedom
for political
prisoners.

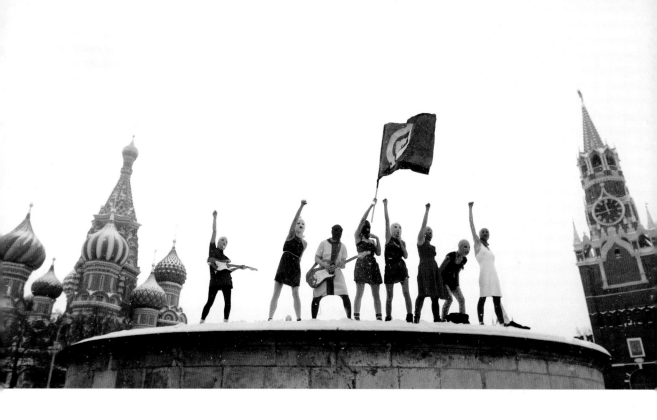

NEON REBELLION

ABOVE: Moscow, Russia, 20 January 2012. On Red Square, eight women in home-made balaclavas, now famously known as the band Pussy Riot, challenge President Putin with their music.

On 20 January 2012, eight women climbed on to a stone platform on Red Square in Moscow, just outside the Kremlin walls. Punching their arms in the air, they performed a rebellious anthem. Lyrics included, 'Show them your freedom / A citizen's anger' and 'Revolt in Russia, Putin pissed his pants!' The police quickly carted off the motley crew, in their balaclavas and startling neon outfits (colours which were designed 'to bring joy to the world'). But Pussy Riot had already made their mark on the world.

The Pussy Riot collective varied their membership for different performances, but all shared anger at developments in Vladimir Putin's Russia. The following month, the band staged a guerrilla performance in Moscow's Cathedral of Christ the Saviour. Their 'Punk Prayer' begged, 'Mother of God, drive Putin out!'

Nadya Tolokonnikova, Masha Alyokhina and Katya Samutsevich were arrested and charged with 'hooliganism motivated by religious hatred'. The women insisted they were simply protesting at the

inappropriate entwining of religion and state politics. They saw their protest in a larger context, with relevance to Russia's own history.

Nadya Tolokonnikova quoted the novelist Alexander Solzhenitsyn, who spent years in Siberian camps, on the possibilities of change in apparently impossible circumstances: 'The word will break concrete.' She told the court, 'Katya, Masha and I may be in prison, but I do not consider us defeated. Just as the dissidents [of the Soviet era] were not defeated … Every day, truth grows more victorious, despite the fact that we remain behind bars.'

The women were jailed for two years. They were released after international pressure ahead of Russia's Winter Olympics in 2014. Today, they continue to highlight human rights issues – including abuses inside Russian jails.

BELOW: Nadya Tolokonnikova of Pussy Riot, in court. 'Katya, Masha and I may be in prison, but I do not consider us defeated.'

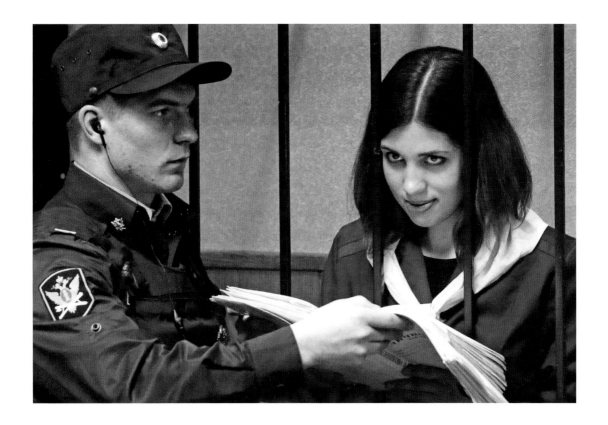

NON-FILMS AND GOLDFISH

'Everything was hidden. The game between director, audience and censor gave us our field of play.'
ANDRZEJ WAJDA, POLISH FILM DIRECTOR

BELOW: Tehran, Iran, June 2009. Jafar Panahi's original crime was to start making a film about the protests of 2009, when millions of Iranians demanded change.

Cinema often finds ways of smuggling prohibited truths large and small to its audience – in Eastern Europe, for example, during the Communist era, and nowhere more so, in recent years, than in the films of Iranian director Jafar Panahi.

In 2010, Panahi was sentenced to six years in jail and – in a backhanded compliment to the power of his art – a twenty-year ban on directing. His immediate crime ('colluding in propaganda') was to have begun a film set against the backdrop of the huge post-election democracy protests that were violently repressed in 2009. Panahi spent three months in Iran's notorious Evin Prison before international pressure led to his release on bail.

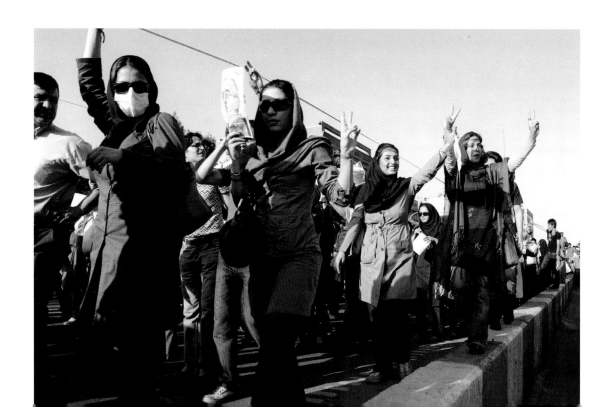

RIGHT: Panahi, seen here in his own film, *Taxi Tehran*.

Such experiences would make most people cautious about their next move. Panahi, however, continued as though (almost) nothing had happened. His next project was called *This Is Not a Film*. (How could it be a film, if Panahi was prohibited from making films?) The film (or non-film) was smuggled out of Iran to the Cannes film festival in 2011 in a flash drive buried inside a cake.

In 2015, while still banned from working and under threat of being sent back to jail (his appeal had been refused), Panahi released *Taxi Tehran*, filmed as he drove a cab around the Iranian capital. *Taxi Tehran* is a gently defiant and partly comic eighty-minute portrait of a society, as seen and heard via the passengers in Panahi's cab. Subjects discussed range from the death penalty and interrogators' blindfolds, to the life and death of goldfish. One passenger (and star of the film) is Panahi's ten-year-old niece Hana, who asks what is the 'sordid realism' that, her teacher has told her, is forbidden in 'distributable' Iranian movies. Her uncle explains, 'There are realities they don't want to be shown.' Hana replies, 'They don't want to show it, but do it themselves? Whatever … I don't get it.'

Another passenger is human rights lawyer Nasrin Sotoudeh, who defended Panahi and other human rights activists, and who has herself been jailed for her work. As she gets out of the taxi, Sotoudeh gives Panahi a red rose. 'This is for the people of cinema – because the people of cinema can be relied on.'

WORTH A THOUSAND WORDS

'They can ban my books, they can ban my cartoons, but they cannot ban my mind.'

ZUNAR, MALAYSIAN CARTOONIST

US Secretary of State Hillary Clinton thought President Bashar al-Assad was 'a reformer'. British prime minister Tony Blair considered giving him an honorary knighthood. For Syrians themselves, the dangers were more obvious.

Cartoonist Ali Ferzat, like his Malaysian colleague Zunar, knew he was taking risks when he used his art to tell unpalatable truths. For decades, Ferzat has lived close to the edge with his allusive images and gained popularity through doing so. Things became particularly difficult when in 2010 he began to draw identifiable individuals, not just generic tyrants. That, as he put it later, pushed him through 'the barrier of fear'.

In one image, Ferzat portrayed the Syrian leader perched on the edge of a massive armchair – Ferzat's familiar 'chair of power'. Sharp springs are popping out of the broken upholstery. In Ferzat's summary, 'Basically, things were starting to give [Assad] a pain in the arse.'

The punishment for such insolence was not long in coming. In August 2011, masked gunmen dragged Ferzat from his car, shattering his hands and leaving his fingers broken. The cartoonist was left by the side of the road.

The attack served as a perverse tribute to the power of Ferzat's work. Even after the attack, he refused to be silenced. Ferzat is critical of international failures, too: 'The West has used the policies of the three monkeys: I do not see, I do not hear and I do not talk.'

A cartoon by Ali Ferzat of the Syrian leader, President Bashar al-Assad. In Ferzat's words, 'Things were starting to give him a pain in the arse.'

NOT A BUG SPLAT

US military drones – remotely controlled killing machines, often operated from an air base in the Nevada desert – have been responsible for the deaths of many civilians in Pakistan and elsewhere. Eight-year-old Nabeela Rehman's grandmother Mamana Bibi was killed by a drone strike in 2012. Nabeela witnessed her grandmother's death. They had been picking okra together in preparation for Eid celebrations the next day. Nabeela told Amnesty International, 'When drones fly overhead, I wonder, will I be next?' Hundreds of children have lost their lives. Nabeela's father said, 'We do not kill our cattle the way the US is killing humans with drones.'

The White House claims 'near-certainty' that non-combatants will not be injured or killed. Those who document the impact on the ground do not see it that way. According to an analysis by the Reprieve human rights group, the rate of intended killing to 'collateral damage' has been twenty-five to one. Children are seen from the air-conditioned trailer in Nevada as a mere blur on the screen. They are described as 'fun-sized terrorists'. One former drone pilot told the *Guardian* newspaper, 'Ever step on ants and never give it another thought? That's what you are made to think of the targets – as just black blobs on a screen.'

Pakistan, 2014.
This giant image
spread out in
a field is an
art installation
targeted at drone
operators who
refer to kills as
bug splats.

The military described those who lost their lives as 'bug splats'. In Pakistan, people were determined to change that. In 2014, local groups, together with a collective of international artists, launched the #NotABugSplat campaign. A vast photograph of a girl, twenty metres by thirty metres, was laid out in a field – easily visible from high in the sky. The girl in the picture had lost both parents and two siblings in a drone attack; she herself was lucky to have survived. The drone operators saw not an anonymous blur but a huge child's face on their screen.

Giving a face to the faceless helped change things. The number of drone attacks – and associated civilian casualties – has in recent years finally started to come down. In 2016, President Obama issued an executive order that should make civilian protection a priority for the first time.

DANGEROUS READINGS

The Cuban artist Tania Bruguera has often got into trouble for her art performances. In her 'Tatlin's Whisper' in 2009, she offered a microphone for Cubans to speak publicly for one minute on any subject they chose. The authorities were seemingly unimpressed by the dangerous incitement for people to exercise the internationally guaranteed right to free speech. They shut Bruguera's performance down.

In May 2015, during the Havana Biennial, Bruguera organized what she called the Hannah Arendt International Institute for Artivism. This involved a hundred-hour reading of Hannah Arendt's *The Origins of Totalitarianism* in Bruguera's Havana home over several days. The book had been published in 1951, before Castro's Cuba even existed, but authoritarian governments share a mistrust of books, and a title that contained the word 'totalitarianism' was obviously alarming. As a result, Bruguera's bookish event was treated as if it were a danger to society.

RIGHT: Havana, May 2015. The copy of *Origins of Totalitarianism* by Hannah Arendt that artist Tania Bruguera read to invited guests.

LEFT: The authorities first tried to drown out her voice with pneumatic drills. Then police took her 'for a little ride'.

The authorities seemed to decide that the words of Arendt – and thus also the voice of Bruguera, as artist – should simply be drowned out. Construction workers were posted outside her window with pneumatic drills. The noise was deafening, and nobody could hear Arendt's words. As so often, the authorities missed the point. Few in the audience would in any case have been able to concentrate on every word of Arendt's book, even without any external disturbance. The context of the performance remained as relevant as the content – and the pneumatic drills placed outside Bruguera's window underlined that.

As Bruguera's event came to an end, the artist was, as she put it, 'taken for a little ride' by police and detained for several hours. Bruguera, whose passport was confiscated while 'waiting for the decision of the prosecutor', argued that the authorities are confused: 'They're desperate and afraid – they lost the symbolic implication of their action … They're extremely afraid of people saying what they think, without fear of consequences.'

'Books and all forms of writing are terror to those who wish to suppress the truth.'
WOLE SOYINKA

A BRUISING RESPONSE

Violence against women is a daily reality in Afghanistan. Most often, it goes unconfronted and unpunished. Artist Kubra Khademi wanted to challenge that. In 2015, she commissioned a metalworker to create a set of armour that fitted over her breasts, belly and buttocks. After all, she said, 'this is all that men see of women'.

Khademi knew she would get strong reactions, but even she did not guess quite how strong. She planned to walk in her body armour through the streets of Kabul, filming reactions of passers-by. The reactions were so extreme that her performance had to be cut short. Her safety was threatened. Khademi was clear: 'I don't have any regrets. Artists can't be stopped.'

Only weeks after Khademi's performance, and reinforcing the seriousness of the issues, came the killing of Farkhunda Malikzada. Farkhunda was beaten by a mob of angry men, run over, set on fire and thrown into a river in Kabul, after being falsely accused of burning a Koran. Across Afghanistan thousands of women (and some men, too) demanded action – painting faces blood-red in reference to Farkhunda's death and, more broadly, in protest against violence against women. Defying tradition, they refused to let men, who had failed to defend Farkhunda, carry her coffin.

The defiance has continued. In 2016, a competitor in *Afghan Star* – a television singing contest, along the lines of *X Factor* and *American Idol* – publicly confronted the violence. Twenty-three-year-old Sahar Arian appeared on stage with smeared make-up and streaks of bloody red paint. Sahar's song addressed the violence all around. She explained, 'I saw what happened to Farkhunda. I wanted to voice both my anger and the anger of all women in Afghanistan.'

Sahar received a standing ovation; she also received death threats. But she was determined not to back down: 'I was a small lamb in a lion's den. But I was not afraid.'

OPPOSITE, TOP: Kabul, Afghanistan, February 2015. Kubra Khademi commissioned a set of armour, which she then wore through the streets. The reactions were extreme.

OPPOSITE, BOTTOM: After the brutal murder of twenty-seven-year-old Farkhunda in March 2015, Afghan women smeared their faces red in solidarity, demanding justice.

· ·

Mockery For Change

'Irreverence is the champion of liberty, and its only sure defence.'
MARK TWAIN

Repressive governments are eager to crack down on dissent when they know they are being challenged. From their perspective, that's the easy part. More complicated is when citizens mock their rulers. Authoritarianism and a sense of humour rarely go together. That's where protesters can gain the upper hand – or at least find an excuse to laugh at their rulers or other powerful players (who, in turn, have little clue how to react).

'Laughtivism' – a reminder that serious issues can also be a laughing matter – can be a winning mixture, even in circumstances where there seems to be little prospect of change. Mischief and humour do not, by themselves, bring solutions. But they can help destroy the sense of invulnerability that unwanted rulers need in order to sustain themselves. For, as the Polish poet Stanisław Barańczak put it in 1978, in the end it turns out that 'they are the ones who are afraid the most'.

Rostock, Germany, 2007. Riot police (and helpers) ahead of a global summit of G-8 governments.

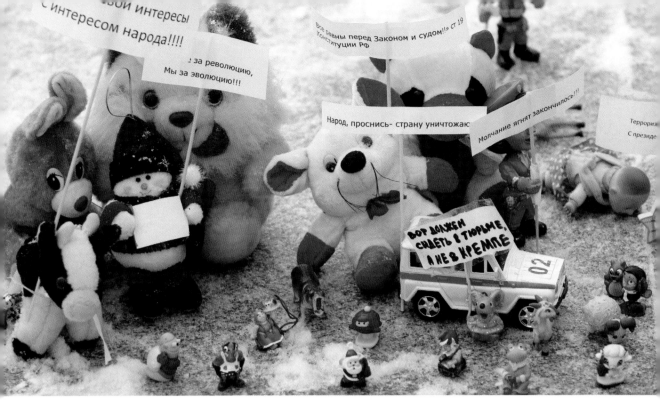

С интересом народа!!!!

...вои интересы

за революцию,
Мы за эволюцию!!!

Все равны перед Законом и судом!!» ст 19
Конституции РФ

Народ, проснись- страну уничтожаю...

Молчание ягнят закончилось!!!

Террори...
С президе...

ВОР ДОЛЖЕН
СИДЕТЬ В ТЮРЬМЕ,
А НЕ В КРЕМЛЕ

02

PUTIN'S GUYS AND
SIBERIAN DOLLS

ABOVE: Barnaul,
Russia, January
2012. Cuddly toys
in the Siberian
snow were seen
by the authorities
as subversive.
The action was
deemed illegal.

In 2011, after eleven years in power, Vladimir Putin announced that he wanted to be president for an unprecedented third term, by creatively re-interpreting existing rules. For many Russians, this was the last straw, especially after evidence had emerged of electoral ballot-stuffing earlier that year. Hundreds of thousands demonstrated in Moscow and across the country, and many were arrested. But it turned out that the authorities weren't just afraid of people.

An assortment of toys – including teddy bears, Kinder Surprise toys and *South Park* figurines – were planted in the snow in the Siberian city of Barnaul as substitute protesters and ambassadors of protest. The toys carried slogans like 'I'm for clean elections' and 'A thief should sit in jail, not in the Kremlin'.

'Freedom is always the freedom of those who think differently.'

ROSA LUXEMBURG

On the face of it, the dolls could hardly have been less threatening. But the authorities reckoned they represented an 'unsanctioned public event'. They noted that the toys were 'not citizens of Russia' ('especially the imported toys'). The protest was banned. Police recorded the slogans in their notebooks, and the action was shared on social media so that Russians could laugh at their rulers' paranoia. For organizer Lyudmila Alexandrova, it was simple: 'We wanted to show the absurdity and farce of officials' struggles with their own people.'

RIGHT: Police carefully noted down the slogans, for possible action against the toys.

PUPPETS AGAINST ASSAD

'You can deal with everything that is scary with laughter.'

'JAMEEL', DIRECTOR OF *TOP GOON: DIARIES OF A LITTLE DICTATOR*

In late 2011, when Syria was already descending into a spiral of violence, a group of courageous Syrians responded not by picking up guns but by creating a puppet show.

Top Goon: Diaries of a Little Dictator included a pastiche of the TV game show *Who Wants to be a Millionaire?* The excitable presenter of *To Kill a Million* referenced the uprisings and death tolls of previous competitors. 'Hosni Mubarak reached three thousand dead! ... Gaddafi reached twenty thousand dead! ... And today ... our new contestant, Bashar al-Assad!! *[cheerful fanfare]*. Our expectation is: he will kill a million!!!'

At that time, nobody could guess how close the satire would

come to reality. But Syrians loved watching the series online, despite and because of its dark humour. The show's director, 'Jameel' (a pseudonym), said the idea was to 'break down the wall of fear'. In any case, he added, 'It gets a little laugh.'

In 2013, the *Top Goon* marionettes performed live in the rebel-held town of Manbij, near Aleppo. Manbij was bombed by Assad's forces as the show was about to begin. The timing of the attack seemed deliberate. But the show went ahead, creating what the performers described as 'a haven in a storm even as tempestuous as Syria's'.

Newer episodes of *Top Goon: Reloaded* address the failures by international politicians to confront the humanitarian catastrophe that has unfolded. Puppets tell truths that politicians on all sides are reluctant to hear.

The assembled puppets of *Top Goon* (opposite) and the chief villain (below) – 'Beeshu', with Assad's distinctive features.

DONKEY-HEADED

In the former Soviet republic of Azerbaijan, human rights activists are harassed or jailed for speaking out about the situation in their country. Even talking about the levels of corruption has become a criminal offence. It can seem difficult to imagine a way of confronting such asinine repression. But asinine became the defining word. In 2009, dissident bloggers organized a mock press conference, with a donkey as honoured guest.

'In Azerbaijan, if you are donkey enough, you can succeed in probably everything,' the donkey-head told a group of respectfully nodding journalists. 'In Azerbaijan, I would try to be even donkeyer than before.'

There was only one glitch, the donkey admitted – that the government of Azerbaijan seems determined to silence the voices of civil society (including, the donkey implied, even the voices of well-meaning animals like himself). 'It will be impossible for me,' the

Azerbaijan, June 2009. A donkey holds a spoof press conference to highlight the absurd levels of repression of free speech.

'Dictatorships foster oppression, dictatorships foster servitude, dictatorships foster cruelty; more abominable is the fact that they foster idiocy.'
JORGE LUIS BORGES

donkey concluded sadly, 'to have any social activity.'

The video of the mock press conference, with the reporters listening attentively to donkeyish absurdities, went viral. The organizers were jailed. After their release, donkey bloggers and prisoners of conscience Adnan Hajizada and Emin Milli remained unrepentant. In Milli's words, 'Spending sixteen months in jail has, of course, made me stronger. It made me believe that the ideals I fight for are very powerful – because otherwise I would not have been put in jail.'

LIES EXPOSE TRUTH

'I fight like hell to pay as little as possible.'
DONALD TRUMP

Around the world, wealthy individuals and companies go to great lengths to avoid paying much (or any) tax. Understandably, many people are unhappy that the rich can find legal ways of paying not more but *less* tax than average citizens.

In 2010, General Electric reported worldwide profits of $14 billion. More than a third of that came from the company's operations in the United States. But, the *New York Times* reported, the multinational giant paid little or no US tax. Indeed, it claimed a tax benefit of $3.2 billion. This 'innovative accounting', as the *New York Times* described it, caused unease. But nothing changed.

Then, however, came an apparent about-turn. Associated Press reported in 2011 that General Electric had had a change of heart. The corporation was intending, the news agency reported, to 'repay its entire $3.2 billion tax refund'. The news caused rejoicing in some quarters. The markets, however, were unimpressed; GE's stock value fell.

Luckily for General Electric, their version of 'sanity' was quickly restored. Their spokespeople jumped in to insist that the news story was false. In reality, they said, they had *no intention* of changing their tax procedures. Whereupon the share price jumped back up. Everything returned to what passed for normal. The responsibility for the 'let's do the decent thing' stunt lay with the Yes Men, professional pranksters with an ethical bent, working together with the pressure group Tax Uncut. In the words of the Yes Men, 'Sometimes it takes a lie to expose the truth.'

Inequality – and the reluctance of the wealthiest to pay the taxes that match their wealth – has been a growing theme around the world. In 2011, the protesters of Occupy Wall Street – and similar protests, including Los Indignados in Spain and Occupy movements

worldwide – demanded change on behalf of 'the 99 per cent', instead of the privileged and powerful 1 per cent.

In 2016, millions of documents known as the 'Panama Papers' were leaked to the German newspaper *Süddeutsche Zeitung* and the International Consortium of Investigative Journalists. The document exposed the global tricks of tax evasion in more graphic detail than ever before. In Iceland, one in fifteen of the entire population of the country went on to the streets of Reykjavik, until the prime minister, who stood accused of hiding millions of dollars offshore, eventually resigned (still insisting he had done nothing wrong).

The pressures for tax reform – for corporations and wealthy individuals alike – continue to grow. In 2016, one enticing headline declared: 'General Electric to Pay Taxes in Boston'. The story turned out to be an April Fool. But who knows: if pressure continues to grow, the fantasy might yet become a reality, in different contexts around the world.

Berlin, April 2016. Activists in suits – and, naturally, Panama hats – demand transparency in connection with revelations of tax evasion by the wealthy on an industrial scale.

PLASTIC DUCKS AND HISTORY

'The struggle of man against power is the struggle of memory against forgetting.'
MILAN KUNDERA

It is sometimes claimed that all in China have long since forgotten the massacre in Tiananmen Square on 4 June 1989, when the Chinese army and security forces killed hundreds of peaceful protesters for daring to demand basic rights. The killings are officially denied. And, at the same time, they are said to be irrelevant to today's concerns. Odd, then, that the authorities have banned a selection of words from internet searches – not just 'Tiananmen massacre', but also 'anniversary', '6/4' and '1989'. But those who want to refer to the bloody anniversary still have a trick or two up their digital sleeves.

In China, one of the most forbidden images of all is the famous photograph of the lone man, armed with nothing but his courage

and a plastic shopping bag, standing in front of a column of tanks near Tiananmen Square. In June 2013, ahead of the anniversary of the killings, four yellow plastic ducks were digitally inserted into the photograph. The tanks were thus erased – and at the same time highlighted and remembered – with children's bath toys. In a single gesture, those who cared about truth both mocked the censors and challenged the cover-up.

The hashtag #bigyellowduck became another way of referring to Tiananmen Square, thus avoiding the censors' intrusive gaze. 'Big yellow duck' became the most popular search phrase on the Chinese social media site Weibo until search engines began to exclude the words, declaring that 'according to relevant laws, statutes and policies' the results of the search 'cannot be shown'.

But it was clear where the small victory lay. In the words of one Twitter user, 'Chinese netizens: 1, Chinese censors: 0'. Commemoration of the murder of hundreds of Chinese citizens can be prohibited. But the subject cannot be entirely suppressed.

IN CONCLUSION

'They're unrealistic . . . It's a pity there is perhaps this small black cloud there, but that's life.'

CHARLES POWELL, FORMER ADVISER TO
MARGARET THATCHER

We can never know who and what will succeed, or when. It is striking, however, how quick some people are to justify an obviously unjust state of affairs – especially if they are not obliged to suffer the injustice personally. Lord Powell, quoted above on the Hong Kong protests of 2014, is not alone in suggesting that protesters shouldn't worry about 'a small black cloud' – in this case, the lack of a free vote. (Some of the umbrella protest leaders clearly didn't receive Lord Powell's memo about the uselessness of protest, when, on being elected to Hong Kong's Legislative Council in 2016, they defiantly misspoke the oath of loyalty to Beijing. Student leader Nathan Law quoted Gandhi, 'You can chain me, you can torture me, you can even destroy this body. But you will never imprison my mind.')

Quite apart from the question of whether Powell's dismissive analysis proves right or wrong in the longer term, the 'Look how unrealistic they are!' rhetoric, still heard in so many contexts, may have implications for the outcome of the protests themselves. The fewer people there are who believe in change, the less likely such change becomes. As Egyptian activist Asmaa Mahfouz argued in her historic Facebook video, quoted in the introduction, those who pour cold water on the courage of others should also take responsibility for the clear implications of their own (in)action. In Mahfouz's own blunt words: 'You are the problem.'

Change is often a slow-burn process, with plenty of reasons for pessimism along the way. But, as history has repeatedly shown, change eventually comes – not least because of the actions of

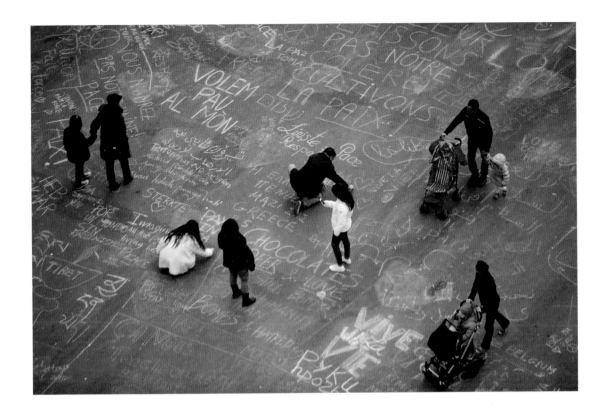

those who are 'unrealistic' in their determination to remove what comfortable outsiders may see as a 'small black cloud'. As the image on this page reminds us, the politics of hate can be confronted, too, by those who refuse to allow hate to triumph.

Around the world, many forms of protest – from prohibited clapping to eating sandwiches, from satire against murderers to press conferences with donkeys, from red-hatted dwarfs to yellow plastic bath-ducks – make more difference than might ever have seemed imaginable.

Ai Weiwei, whose creative mischief has so often got him into trouble, once posed the question, 'Imagine one day the hateful world around you collapses and it's your attitude, words and actions that have put an end to it. Will you be excited?'

What comes next depends on all of us.

Brussels, March 2016. Against hatred, believing in better.

ACKNOWLEDGEMENTS

· ·

Thanks to Salil Shetty and colleagues at Amnesty International for encouraging the sabbatical that enabled me to write this book. Thanks to Chetan Bhatt and the Centre for the Study of Human Rights at the London School of Economics, for the space and support provided by a Visiting Fellowship at the Centre in 2015–16.

Renewed thanks to John Jackson for our book collaboration on *Small Acts of Resistance* six years ago, which was triggered originally by an energizing dinner conversation in New York in 2007. That conversation led to many different things, including indirectly to *Street Spirit*. One way and another, it proved a productive dinner.

Thanks to many people who have suggested stories, corrected errors, or helped refine and challenge my ideas. Among a long list, these include: Masih Alinejad, Esteban Beltrán, Nicholas Bequelin, Dorothy Byrne, Lucas Delattre, Andrew Gardner, André Gazut, Fredrik Gertten, David Griffiths, Sally Jeffery, Denis Krivosheev, Darryl Leung, Philip Luther, Bronwen Manby, Andrew Marshall, Marianne Møllmann, Horia Mosadiq, Sergei Nikitin, Srdja Popović, Tom Porteous, Mustafa Qadri, David Usborne, Wuer Kaixi and (last but definitely not least) Sam Zarifi.

Opinions are (obviously) my own.

Many thanks to all at Michael O'Mara – including Adrian Greenwood, who believed in the idea of the book long before a word had been written; Hugh Barker, who helped shape the direction and gave the unwritten book a name; Judith Palmer, for her work in sourcing great images; and Fiona Slater, who has tightened and improved the manuscript at every turn.

And, finally, thanks as always to Eva and Ania for tolerance and encouragement in equal measure, and for making this book much better than it would otherwise be, in more ways than I can count.

BIBLIOGRAPHY

Ackerman, Peter, and Duvall, Jack, *A Force More Powerful: A Century of Nonviolent Conflict*. New York: Palgrave, 2000.

Banerjee, Mukulika, *The Pathan Unarmed*. Oxford: Oxford University Press, 2000.

De Bollardière, Jacques Pâris, *Bataille d'Alger, bataille de l'homme*. Paris: Desclée De Brouwer, 1972.

Chenoweth, Erica, and Stephan, Maria, *Why Civil Resistance Works: The Strategic Logic of Nonviolent Conflict*. New York: Columbia University Press, 2011.

Crawshaw, Steve, and Jackson, John, *Small Acts of Resistance: How Courage, Tenacity and Ingenuity Can Change the World*. New York: Sterling, 2010.

Easwaran, Eknath, *Nonviolent Soldier of Islam*. Tomales: Nilgiri Press, 1999.

Fenton, James, *The Snap Revolution*. Cambridge: Granta, 1986.

Fisher, Jo, *Mothers of the Disappeared*. London: Zed Books, 1989.

Freeman, Cathy, *Cathy: My Autobiography*. Sydney: Viking, 2003.

Fydrych, Waldemar (ed. Gavin Grindon), *Lives of the Orange Men: A Biographical History of the Polish Orange Alternative Movement*. Wivenhoe: Minor Compositions, 2014.

Gertten, Fredrik (dir.), *Big Boys Gone Bananas!**, 2012.

Gessen, Masha, *Words Will Break Cement: The Passion of Pussy Riot*. London: Granta, 2014.

Halasa, Malu, Omareeen, Zaher, and Mahfoud, Nawara, *Syria Speaks: Art and Culture from the Frontline*. London: Saqi Books, 2014.

Halberstam, David, *The Children*. New York: Random House, 1998.

Harding, Luke, *The Snowden Files*. London: Guardian Books, 2014.

Havel, Václav, *Living in Truth*. London: Faber & Faber, 1987.

Lewis, John, *Walking With the Wind: A Memoir of the Movement*. New York: Simon & Schuster, 1998.

Michnik, Adam, *Letters from Prison and Other Essays*. Berkeley, California: University of California Press, 1985.

Poitras, Laura (dir.), *Citizenfour*, 2014.

Popović, Srdja, and Miller, Matthew, *Blueprint for Revolution*. London: Scribe Books, 2015.

Roberts, Adam, and Garton Ash, Timothy (eds.), *Civil Resistance and Power Politics: The Experience of Non-violent Action From Gandhi to the Present*. Oxford: Oxford University Press, 2009.

Sharp, Gene, *From Dictatorship to Democracy*. London: Serpent's Tail, 2011.

Simpson, John, and Bennett, Jana, *The Disappeared and the Mothers of the Plaza*. New York: St Martin's Press, 1985.

Soueif, Ahdaf, *Cairo: Memoir of a City Transformed*. London: Bloomsbury, 2014.

PICTURE CREDITS

Contents
Page 4 © Steve Crawshaw

Foreword
Page 6 © Ai Weiwei

Introduction
Page 8 © Marco Longari / AFP / Getty Images

Chapter One
Page 22 © Sergei Grits / AP / PA Images; page 24 © Vasily Fedosenko / Reuters; page 25 © Sergei Grits / AP / PA Images; page 26 © Carlos Barria / Reuters; page 27 © Eugene Hoshiko / AP / PA Images; page 28 © Paula Bronstein / Getty Images; page 29 © Alex Ogle / AFP / Getty Images; page 31 (top) © Narong Sangnak / EPA / Alamy; page 31 (bottom) © Yostorn Triyos / Demotix / PA Images; page 32 (left) © Poster by Jacek 'Ponton' Jankowski, courtesy of Orange Alternative Museum; page 32 (right) photo © Tomasz Sikorski, 1983; page 33 photo © Mieczysław Michalak, courtesy of Orange Alternative Museum; page 34 © Marko Djurica / Reuters; page 35 © Murad Sezer / Reuters

Chapter Two
Page 36 © Robert Atanasovski / AFP / Getty Images; page 39 © courtesy of My Stealthy Freedom; page 40 © Marwan Naamani / AFP / Getty Images; page 41 © Hassan Ammar / AP / PA Images; page 43 (top) © Sarah McBride; page 43 (bottom)

© Sara D. Davis / Getty Images; page 45 (top) © Ebrahim Hamid / AFP / Getty Images; page 46 © Jeff Vinnick / Reuters; page 48 © Aaron P. Bernstein / Getty Images; page 49 © Janek Skarzynski / AFP / Getty Images; page 50 © courtesy of Fabian Wichmann / www.rechtsgegenrechts.de; page 51 © courtesy of Fabian Wichmann / www.rechtsgegenrechts.de

Chapter Three
Page 52 © Marc Riboud / Magnum Photos; page 55 © Dinodia Photos / Alamy; page 56 © Bettmann Archive / Getty Images; page 57 © Paul Schutzer / The LIFE Picture Collection / Getty Images; page 59 © Jonathan Bachman / Reuters; page 61 © Peter Reyes/*The Manila Times*; page 62 © Maxim Zmeyev / Reuters

Chapter Four
Page 64 © The Indian Express; page 67 © CKN / Getty Images; page 68 © Mohammed Seeneen / AP / PA Images; page 69 © Mohammed Seeneen / AP / PA Images; page 71 photo © W G Film, from *Bananas!** (2009), directed by Fredrik Gertten and produced by WG Film; page 72 © Elvis Barukcic / AFP / Getty Images; page 73 © Elvis Barukcic / AFP / Getty Images; page 75 (top) © Jacques Grevin / Intercontinentale / AFP / Getty Images; page 75 (bottom) © AFP / Getty

Images; page 77 © Guardian News & Media Ltd 2016

Chapter Five
Page 78 © Igor Gavrilov / The LIFE Picture Collection / Getty Images; page 81 © Daniel Garcia / AFP / Getty Images; page 82 © Andrey Solovyov / AFP / Getty Images; page 85 © Emilio Morenatti / AP / PA Images; page 86 (left) © Fethi Belaid / AFP / Getty Images; page 86 (right) © Raqqa Media Center / AP / PA Images; pages 88-9 © courtesy of Amnesty International

Chapter Six
Page 90 © Reuters / Trend Photo Agency / Handout; page 93 © David Reed / Alamy; page 95 © Museo Nacional Centro de Arte Reina Sofia; page 96 © Denis Sinyakov / Reuters; page 97 © Mikhail Metzel / AP / PA Images; page 98 © Kaveh Kazemi / Getty Images; page 99 © courtesy of New Wave Films; page 101 © courtesy of Ali Ferzat; pages 102-3 © courtesy of Saks Afridi and www.notabugsplat. com; page 104 © courtesy of INSTAR and Yo Tambien Exijo Platform; page 105 © courtesy of INSTAR and Yo Tambien Exijo Platform; page 107 (top) © Massoud Hossaini / AP / PA Images; page 107 (bottom) © Shah Marai / AFP / Getty Images

Chapter Seven
Page 108 © Fabian Bimmer / AP / PA Images; page 110 © Andrei Kasprishin /

Reuters; page 111 © Andrei Kasprishin / Reuters; page 112 © Masasit Mati; page 113 © Masasit Mati; page 114 © still courtesy of the video's author, Adnan Hajizada; page 117 © Sean Gallup / Getty Images; page 118 © weibo.com/weiblog; page 119 © Jeff Widener / AP / PA Images

In Conclusion
Page 121 © Kenzo Tribouillard / AFP / Getty Images

About the Author
Page 128 © Jens Tukiendorf

INDEX

ABOUT THE AUTHOR

Steve Crawshaw is Director of the Office of the Secretary General at Amnesty International, which he joined as international advocacy director in 2010. From 2002 to 2010, he was UK director and UN advocacy director at Human Rights Watch. He joined the *Independent* at launch in 1986, where he reported on the eastern European revolutions, the collapse of the Soviet Union and the Balkan wars.

He is co-author with John Jackson of *Small Acts of Resistance: How Courage, Tenacity and Ingenuity Can Change the World*, preface by Václav Havel. His previous books were *Easier Fatherland: Germany and the Twenty-First Century* and *Goodbye to the USSR: The Collapse of Soviet Power*.

He studied Russian and German at the universities of Oxford and Leningrad (St Petersburg), and lived in Poland from 1978 to 1981.